BREWING IN BRITAIN
An Illustrated History

Ken Smith and the Brewery
History Society

Beer! Happy produce of our isle
Can sinewy strength impart
And wearied with fatigue and toil
Can cheer each manly heart.

First published 2016

Amberley Publishing
The Hill, Stroud
Gloucestershire, GL5 4EP

www.amberley-books.com

ISBN 978 1 4456 5316 7 (print)
ISBN 978 1 4456 5317 4 (ebook)

British Library Cataloguing in Publication Data.
A catalogue record for this book is available from
the British Library.

Typeset in 10pt on 13pt Celeste.
Typesetting by Amberley Publishing.
Printed in the UK.

Contents

In the Beginning

Welcome!

So nice to have your company.

May I assume from the fact that you are reading this that you enjoy a glass of beer? And why not!

You cannot deny that it is a very social drink, designed to be consumed in pleasant surroundings and with people whose company you enjoy. Well, your company is most welcome on this, a brief journey through the history of that drink as it developed, both within the British Isles and worldwide.

First of all let me ask you a question: how old was the last glass of beer you consumed? No, I don't mean what was the sell-by date on the bottle or can, nor the age of the keg the publican extracted it from; I mean, how old is beer itself?

If you take a broad view and say that beer, or ale if you prefer, is a malted alcoholic drink then I can safely say the age of this brew is at least 6,000 years. I say 'at least 6,000 years' simply because we can support that statement with solid facts. It is certainly possible that the birth of brewing coincides very neatly with the birth of organised agriculture.

Think of all the major events in human history that beer and ale have witnessed. The development of towns and cities, the building of the pyramids, the rise and fall of Rome, the expansion of the British Empire and the birth and development of the Industrial Age. Not to mention the celebrations that would have followed the launch of, say, personal computers or the mobile phone. That beer of yours has seen it all. One might say that all of humankind's achievements were reflected in an unassuming glass of beer.

I see you are somewhat apprehensive about such statements. I don't blame you, however I can prove most of my claims with hard, empirical evidence. So let's get started.

The proof of the minimum age of beer comes from archaeologists working in the Middle East, researching the Sumerian civilisation. They have repeatedly uncovered remains of pottery in which are embedded spent wild grass seeds – not really surprising given that within the fertile spaces surrounding the Tigris and Euphrates rivers, where the Sumerians lived, there were dozens of different varieties of wild grasses growing. A veritable greengrocers of edible foodstuff.

What this evidence proves is that one of civilisation's 'very good ideas', possibly our best (no offence meant to the wheel), was to harvest these grasses and turn them into foodstuff for nourishment. The assumption was that these grains were used initially to eat unprocessed but eventually to produce coarse bread. However, alongside the bread production came another sort of grain processing – brewing. After all, beer has for centuries been described as liquid bread. Another 'very good idea' that emerged round this time was that rather than harvest the seeds of these grasses by roaming far and wide, could

they not be encouraged to grow somewhere the people wanted them to rather than where nature and the wind deposited them?

Whether they were cultivated because the seeds were needed for bread or for beer is hotly disputed and there is little evidence to settle which came first. Nevertheless, a good idea had suddenly become a great idea, possibly the biggest mankind ever had! Organised agriculture had been born. After all, controlling where and when these essential foodstuffs grew allowed the peoples of the age to settle and discard their previously nomadic existence. No longer would they be following their food at the whim of the herds and of the natural growing cycles. They could settle down and form villages, and of course eventually cities – there, I said it was a 'very good idea'. The need of a refreshing beer, the foundation of civilisation.

The evidence collected from the Sumerian sites showed that they were quite accomplished brewers, implying that the process itself had been around for some time – more grist to the mill that beer stimulated organised agriculture. After all it was relatively easy to crush loaves of bread with water and leave them to ferment, thus producing beer, but surely some bright spark would have spotted that they could cut out the middle man, the baker in this case, and produce the beer direct from the grain. That same leap of invention could also take the entrepreneur of the day to stop looking high and low for the grain and start controlling its location with fields and rows and harvests.

You will have noticed that I mentioned fermentation, a key part of brewing. One of the things that was happening to the brews of the time was natural fermentation. Not until Pasteur started peering down his microscope in the nineteenth century did this process become fully understood. However, in these early days there was a huge degree of mysticism about the whole process. The mix magically became alcoholic just by leaving it out for a period. Of course we now know there was nothing magical about it at all, the natural wild yeasts in the air were instrumental in turning a mash of grain and water into an alcoholic drink that would so immediately influence people's behavior. At the time it was baffling. The brewing vessels must have frequently become infected as a result of careless handling and poor hygiene, but nevertheless it was soon a very popular beverage.

To the Sumerians, fermentation was so baffling that at the time it was seen as the result of divine intervention; so divine and so inflectional on peoples' actions that it called for a deity. After all, the deities of the age had the power to make humans suffer and suffer they did – well the next morning they did. They were quick to allocate a goddess to the task – Ninkasi, the embodiment of beer. We still have clay tablets reflecting the powers of this goddess and a poem to her name that also handily contains instructions on how to brew.

Brewing passed from Sumeria to Babylonia, who expanded the idea. They used it in religious ceremonies where drink offerings were considered important to please the gods on whom the people were dependant for the success of the harvest. Sophistication in brewing increased as surviving text discussed the suitability of different types of cereal for brewing purposes. The link between the bread and beer of the time remained strong as the Babylonian word for beer was *kas*, and it can be seen in ancient texts as the word *kasninda*, which means 'beer loaf'. The brewer was known as *lukasninda*, or 'the man of the beer loaf'.

Ales were subsequently flavoured with honey or syrups with dates or figs added. It was fashionable to drink the brew from large jars using straws or tubes. A tablet in the British Museum refers to an 'ale-house' near Babylon about the year 2225 BC.

Despite the popularity of beer, the danger of excess was fully recognised, and the young were admonished as follows: 'When thou drinkest till the demon seizes thy heart, and the words of thy tongue thou canst no more guard then careless speech may destroy thy career, and the next day wilt thou be unable to work.'

The next great civilisation to emerge from the Middle East was the Egyptians. They knew a good idea when they saw it and quickly used the drink to quench the thirsts of those who toiled on the great civil engineering works of the time, the pyramids. What better way to keep up a building schedule than to arrange for drink to be on tap, hopefully at the end of the shift? Again, there is a lot of evidence of this in the shape of large-scale breweries which have been uncovered close to the sites of the townships housing the workers. The idea of rewarding your workers with beer is a theme that returns to our story during the eighteenth and nineteenth century, a trick that didn't really die out until the 1960s and 1970s.

As well as leaving us the magnificence that are the pyramids, the Egyptians gave modern-day Britain other drinking customs. When you are next in your local pub, inn or tavern, take a quick look outside. I'm almost certain that you walked past the very familiar pub sign that adorns most of our public houses; we rarely give it a second thought. Don't be too surprised when I tell you that the Egyptians invented this. They would use a sign – often just a bush or a stick – to signify that this was a place where ale is brewed and ale is for sale. The leaders of Egypt, not content with building the most fabulous structures in the world, saw the opportunity to make a few shekels out of the drinking man. They reasoned that as this drink was so popular they could use it as a way of raising taxes – hence the duty payable on any beer today can be traced back to a time when all that was to be done in an ordinary bloke's day was simply to build one of the world's greatest monuments. However, not satisfied with controlling the price of beer they went one step further and began to license the premises – the license of course had to be purchased and granted by the state.

While we are visiting, one more little fact familiar today that was born in the Egyptian dynasty: when you are next in that local of yours and the landlord calls 'time gentlemen please', remember that the Egyptians, having created a drinking culture just to get the job done, then had to find a way of controlling it. So along with the license went a limit on how long these places could be open for. Getting the workers back to their toil was key. This is a very familiar theme, and on page 85 you can see what the great Lloyd George had to say about it in 1915.

The authorities in Egypt became alarmed at the popularity of ale and its effects upon the populace and tried to restrict the number of ale shops, whereupon the ale drinkers, alert then as now to state tinkering with their pastime, raised a mighty uproar. Prohibition? Eat your hearts out America! So it is fair to say that modern drinking practices and customs all started with the realisation by the Egyptians that this drink gave them the power to control the working population. However, it has to be pointed out that at some points during the

Egyptian dynasties, the people rose against the government and the brewers when they felt that the strength of their favourite tipple had been weakened.

To be fair, the ale of the time was more than a working man's beverage. It formed an important part of sacrifices: King Ramses III offered for sacrificial purposes during his reign no less than 466,303 jugs of beer. Again in common with subsequent hierarchies, the Egyptian aristocracy, such as the priests and rulers, kept the ale for the workers while preferring wine themselves.

The Romans

When the Roman legions first arrived in Britain in AD 43, even the most optimistic foot soldier would not have held out much hope for acres of vineyards and tempting local wines in such a cool climate. What they discovered was that the local population were keen followers of two types of drink: mead, made from honey, and a malted cereal-based drink made from locally grown grasses. Whether they were disappointed that the art of brewing had reached these northern shores of ours many years before Julius Caesar, Claudius and their conquering hordes is not recorded. Heaven knows what the wine-drinking soldiers of the legions thought about these two contrasting drinks. What we do know is that in a remote fort (Vindlandia) adjacent to Hadrian's Wall a series of tablets have been uncovered that show that the Romans were not totally put off by these local brews. Among the notes to loved ones and simple shopping lists are several that record orders made by the thirsty squaddies to local indigenous brewers for ale. This fortuitous peep into everyday life in Roman Britain shows that rather than try and brew their own, the soldiers simply bought it in. A very early example of British commercial brewing, there is no record of whether they enjoyed the local ales.

How the art of brewing preceded the all-powerful Roman legions to these shores is easy to explain. The centre of ale production shifted from the Middle East to Northern Europe about 2,000 years ago. It is assumed that the Israelites brought their skills of brewing when they fled from Egypt. It is also assumed that the Phoenicians, who were well-known world traders, probably brought it to Northern Europe. It can be further assumed, at least for our simple story, that the arrival of cultivated cereals into Britain also brought with it the art of brewing, so when the Romans arrived there was already a widespread ale-drinking culture. Undoubtedly, the Greeks learned brewing from the Egyptians and they then in turn taught the Romans how to create this influential and popular drink. While the Roman way of life preferred wine as standard refreshment, they knew a good thing when they saw it and supplied the populace that their legions were confronting. Ale was used as one of the rations to feed the Roman soldiers in this area. They also used it as a way to bring the local population of conquered lands into the Roman Empire. Roman chroniclers of the time reflected on this preoccupation for the drink, referring to us Brits, as they had done others in the northern parts of their Empire, as 'sons of malt'. Just as the Egyptians had done, they used the ale supply as another method of crowd control.

Pliny the Elder, a well-known documenter of the age, describes 'barley beverages' but dismisses them as drinks only popular in Northern Europe. Through the writings of Pliny and his contemporaries we know that hops were a familiar plant of the time. However, it is not clear whether any link between hops and ale had been made. The hop was employed in a number of ways in ancient Greece.

Dioscorides, an AD first-century Greek physician, states that the Britons and the Hibernia used a liquor called *courni*, or *coirm*, made from barley. A canny commentator of the time observed, probably from personal experience, that 'Kourmi made from barley and often drunk instead of wine, produces headaches.' Pliny describes the drink: 'they employ the foam which thickens upon the surface', which implies the effect of yeast upon the brew. He also comments on the drinking culture: 'The whole world is addicted to drunkenness. Western nations intoxicate themselves by means of moistened grain.'

As the Romans departed Britain, the natives and those Romans that chose to remain settled down to a long period of uncertainty and upheaval. We know that ale brewing was happening in Ireland as the *Senchus Mor*, the book of the ancient laws of Ireland written in AD 438–441, records a number of references to growing barley for subsequent malting. It states that ale is a most popular drink and describes the alehouses that sell the dark brew. The book also mentions that among the household of St Patrick was a brewer called Mescan.

The brewing of ale remained, as it had for many centuries, a domestic affair. Only small quantities were sold through the emerging alehouse and monasteries. This situation was to remain very much unchanged until the turmoil of the late seventeenth and early eighteenth centuries, but more of that later.

With the passage of time we Brits decided that ale was the most nourishing drink, and consolidated a belief and a practice we have adhered to ever since. Ale was brewed in the home, brewed by innkeepers and brewed by monks in the all-powerful monasteries. Fountains Abbey in North Yorkshire even had floors devoted to malting.

Medieval Times

The void left by the departing Romans was soon filled by incoming invaders. The Nordic and Teutonic tribes who ventured into the British Isles were already 'sons of malt', as the Roman chroniclers had labelled them, and knew how to brew a decent pint. It is clear that the Anglo-Saxons were serious and dedicated drinkers. Just like the Egyptians before them, ale was used in a wide range of ceremonies, both good and bad. As before, the art of brewing was entrusted to the women of the tribes. In fact Alreck, King of Hordoland, married his queen Geirhild simply because she was a reputed brewer of good ale. Popular myths show them as marauders and warriors but they encouraged the locals to carry on brewing and even made suggestions for improvements, or at least adaption to their preferred style of ale. Anglo-Saxons considered ale to be medicinal, partly because the ale was mixed with an assortment of additives, one of them being hops, but more of that later.

So popular was the drink that like his Egyptian predecessor, in AD 616 Ethelbert, King of Kent, found the need to regulate ale sellers. By 959 another ruler, King Edgar, was fairly certain that drunkenness was destroying his kingdom. Heavily influenced by his spin doctor, Archbishop Dunstan, he drew up a package of laws aimed to tackle the problem as they saw it, firstly by declaring, 'There shall be one system of measurement and one standard of weights'. Together, they also decreed that there should be only one alehouse per village. Whether this was the birth of the metric-busting pint measure, who can say? Edgar then tried to reduce the amount that his subjects drank when they were in the alehouse. Perversely, he ordained that nails or pins should be placed at measured regular intervals inside each drinking vessel. Each person should only drink down one measure or face severe punishment. This gave rise to a number of drinking games to show the expertise and skill of the warrior who was able to drink exactly a measured amount. Inevitably the term 'to take him down a peg or two' is thought to originate from this law, but again, it cannot be certain. In any case, how would such a law be policed?

When William and his Norman hordes arrived as the final invaders of the British Isles, they wanted to know what they had acquired. So, the famous Domesday Book was compiled. In this there are references to *cervasii* (breweries) and vineyards. William held many feasts and banquets to celebrate his great victory and the acquisition of the country. Menus indicate that the ale was usually provided from local brewers and was of utmost importance. In 1158 there are records of ale being exported back to France, maybe the 'English Normans' were trying to get their cousins back home interested in the newly found drink.

Possibly we can blame Henry II for the state taxes that ale, and beer eventually, have attracted. In 1188 he imposed one on ale to attempt to fund his war on Saladin. This seemed to have worked well as it was repeated by the state in 1228 and 1488.

The City of London councillors had the foresight in 1189 to issue a decree ordering preventative measures to be taken to limit the outbreak of fire in the already cramped metropolis. Brewhouses came in for particular focus, demanding that they be made of stone rather than wood and straw. A good idea but sadly, nearly 500 years later, it was the bakers of Pudding Lane who caused the Great Fire, not the brewers. At the end of the twelfth century the secretary to Thomas Beckett, one William Fitz Stephen, wrote of London: 'The only plagues of London are the immoderate drinking of fools and the frequency of fires.' Having mentioned the unfortunate clergyman, it is worth noting that when at St Albans Abbey in 1158, he was a brewer. Later in his career he made a journey to visit the King of France with several barrels of ale bound with iron hoops as a gift for his majesty – seems we were determined to get them drinking our ale.

Throughout this period the traditions laid down by the Egyptians were not forgotten, even if they were not recognised as coming from them. The idea of displaying a sign to show that freshly brewed ale was for sale here continued. Some of the alehouses got a little carried away with the idea, as in 1375 it was reported that ale stakes were impeding riders and causing wagoners to weave an erratic route through some towns. The use of an ale stake was made legally binding in 1393 when it was an offence to offer ale for sale without one. In 1461 a brewer called Kentroppe was fined 6d for brewing three times without changing the ale stake. By the end of the seventeenth century the use of an ale stake to indicate a fresh brew had all but died out in favour of the familiar inn sign.

One of the characteristics that makes us British is that we just want our share of things to be fair. So it is not surprising that around this time we looked at what we were getting as a 'standard measure' with an eyebrow raised and doubt in our voices. This desire for value for money is so strong that in chapter/clause 35 of all versions and rewrites of one of the world's most influential documents, the Magna Carta, there is a demand to 'Let there be one measure for wine throughout our kingdom, and one measure for ale, and one measure for corn.'

As a result, in 1266 Henry III created the Assize of Bread and Ale. The easiest way to think of this is to compare it to the modern-day Trading Standard and Retail Price Index. The price of barley was monitored and sometimes controlled to ensure the price was stable. The Assize stated that,

> ... brewers in cities ought and may well afford to sell two gallons of ale for a penny and out of cities to sell three gallons for a penny. And when in town three gallons is sold for a penny, out of town they ought and may sell for four. And this assize ought to be holden throughout England.

Stern stuff indeed. This was in place for over 300 years and kept prices 'indexed linked'; it also made sure prices were state controlled. This process was rolled out nationwide.

Between 1300 and 1800 there were numerous attempts to define or otherwise establish a standard measure, but none of these were completely successful. An early attempt at a gallon was in the Tract of Weights and Measures of 1303. This fixed the gallon as the

volume of 8 pounds of wheat, and out of this evolved Henry VII's Winchester gallon, containing 270 cubic inches, and ultimately the modern imperial gallon of 277 cubic inches. In 1423 a statute set the capacity of a hogshead as sixty-three old wine gallons, perversely basing one ill-defined measure on another. During the reign of Henry VIII, legal capacities of several other casks sizes were set out by statute. The London ale barrel was standardised at 32 gallons, the country ale and beer barrel both at 34 gallons and the London beer barrel at 36 gallons. To add to the confusion various names were given to the different sized containers, as well as hogsheads we had the butt, Oporto pipe, Queen's pipe, puncheon, piggin, kilderkin, firkin, pin, keve, kier, cask, tub, tierce, bucket, vat and tank. I have no intention of going any further into this linguistic and mathematical morass made more difficult with the recent introduction of metric measures, it is all far too complex for my simple tale, let's treat this as your homework.

Of course, with all these attempts at standardisation and quality control, it created a role for someone to actually measure the final product: enter the aleconner or aletaster. Simply put, his job was to tour the outlets of ale in his area and report back on short measures and poor quality. Shakespeare's father was one, appointed by the elders of Stratford in 1556. The role appears on the surface as just a salaried pub crawl, paid for by the local authority. However, in reality it carried with it a high degree of responsibility and power. The local aleconner could close a business and put the brewer and their family out on the street. The councillors of the City of London actually produced a job specification for their aleconners in 1377, including the requirement to take an oath: 'You shall swear that you shall know of no brewer or Brewster ... that sells the gallon of best ale for more than one penny halfpenny, or otherwise than by measure sealed and full of clear ale ... And that you shall be required to taste any ale of a brewer or brewster.'

Ale mythology has a number of tales about how an aleconner knew whether the brew he tasted was good. However, those loose stories, amusing as they are, are for another publication, not this one! What does appear to be true is that the aleconner had an official uniform consisting of leather britches. What he did with the breeches and the brew has been twisted and corrupted over time. Suffice to say he either condemned the brew or enthused widely about it – not quite the scientific techniques employed by today's Environmental Health and Trading Standard Officers, but sufficient for the day. By 1758 the term aleconner had been replaced by Clerk of the Market. Just like so many modern-day managerial reorganisations, the role remained the same and just the name changed.

In 1555 the monarch once again got involved with brewing when Mary I saw fit to ban the export of ale as a way of preventing the loss of valuable timber in the barrels the brew was shipped in. This was needed for the building of ships, which reminds me to mention that barrels, whatever size the current standard happened to be, were the staple of our developing nation. Everything was shipped in them, not just ale. For hundreds of years the humble barrel has moved or stored most commodities. What made it such a successful container? They are exceptionally strong, easy to roll and to turn even when fully loaded. This was very important at a time when the only motive power was man or animal. Some goods actually improved inside the barrel.

As the sixteenth century closed, the brewing industry was slowly emerging from its domesticity into a world of expanding markets and opportunities. The brewers were poised to grow and two great centres of national brewing were emerging: London and Burton.

London of course had always been a hive of humanity and the brewers were starting to see how they could supply the ever demanding appetites of the city dwellers. Burton was no sluggard either. Ale had been brewed there for hundreds of years and the purity and properties of the water had been known for some time. Most of the early brewing was done in the monasteries of the area. When Queen Elizabeth I visited nearby Tutbury Castle she asked where she could obtain some ale: 'At Burton three myles off' came the reply. Within 100 years of the queen's visit, the Burton brewers were selling their brews in London, thus creating direct competition. In 1630, Burton beer was regularly on sale in London at the Peacock Inn, Grays Inn Lane, London, which had had regular supplies for many years. This early export of ale from the area was helped by improvements to the rivers and the emerging canal networks. This in turn helped to establish overseas trade, mainly with Russia. It was reported that Peter the Great's empress, Catherine, loved Burton Ale. Indeed, it became fashionable to include the word Russia and Russian in many of the commercial product names used by the brewers. As well as Russia, the Burton brewers began to export to India.

Possibly the most historically influential example of British export expertise came in 1620 when the Pilgrim Fathers took the *Mayflower* on that fateful journey to the New World. Not only did they export beer aboard ship, but found that beer was already there when they arrived. One of the first Native Americans they made friends with during their first few months was a lesser chief of the Wampanoag tribe known as Samorset. He was described by writers of the time as a lover of ale and myth has it that his first words to the settlers, in English, were 'Got any beer?' The tribe helped the newly arrived settlers to brew with the locally available cereals. It also implies that beer brewing was endemic at the time – maybe the traditional American Thanksgiving dinner should not centre on turkey but on beer.

Exporting beer soon became big business. Even after the American War of Independence, the newly created Americans imported large amounts of foodstuff from England. George Washington had a taste for porter and frequently ordered barrels direct from London. Following his success as leader of the independence, he employed a Richard Hare who had set up a brewery in Philadelphia. This was a wise move as Hare was the son of a brewer from London (a firm later to become very large indeed as Taylor Walker of Limehouse). The Washington family home, Mount Vernon, was supplied for some considerable time.

At the other end of the world, settlers in the early penal colonies in Australia would celebrate their safe arrival with a toast in porter.

Opposite above: Airey's Brewery Ltd, Victoria Brewery, Westwood Road, Poolstock, Wigan. Founded by Thomas Airey 1869 and brewed at various sites before the Victoria Brewery was acquired by 1898. Registered November 1906. Acquired by Walker Cain Ltd in 1926 with about forty tied houses that were transferred to the Oldfield Brewery Ltd in 1933.

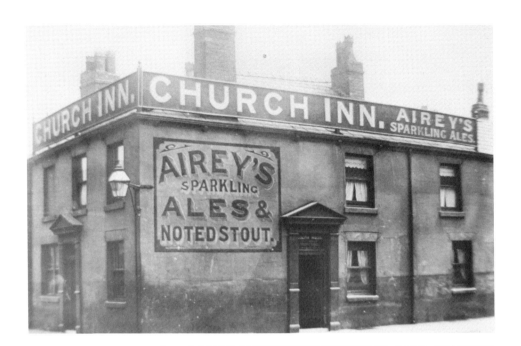

Right: James
Aitken & Co.
(Falkirk) Ltd,
17 Lint Riggs,
Falkirk. Founded
by James
Aitken 1740.
Registered June
1900. Acquired
by United
Caledonian
Breweries 1960.
Brewing ceased in
1966.

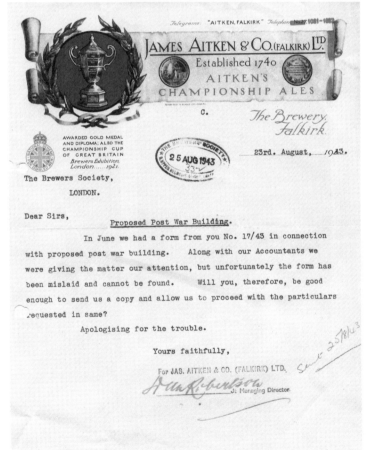

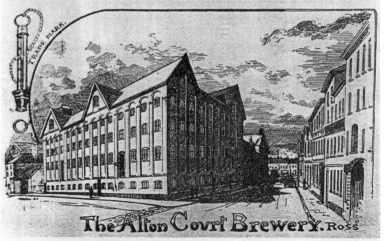

CELEBRATED FAMILY ALES
Brewed from the very best Barley-Malt and Hops.

The Alton Court Brewery. Ross.

Just off Broad Street, filling almost the entire length of Station Street and a good deal of Henry Street there was until 1957 the Alton Court Brewery. Although many years have passed since beer was made here the old buildings still look very much the same as they did in the late nineteenth century, the date of the engraving above. A brief account of this old company has already been dealt with in an earlier book of mine. Therefore, for a moment, let those who especially like a glass of beer, mull over the prices seen below.

LIST OF PRICES.

MILD ALES.

NO.		Per Gal.	NO.		Per Gal.
1	X Harvest Ale		4	AX	1/2
2	XX	-/10	5	AXX	1/4
3	XXX	1/-	6	AXXX	1/6

BITTER ALES.

7	Diamond Pale Ale	1/2	9	India Pale Ale	1/6
8	,, ,,	1/4	10	East India Pale Ale ..	1/8

STOUTS.

11	Porter	1/2	12	Stout	1/4

CELEBRATED FAMILY ALES.

13	Golden Crown	1/-	14	Golden Hop	1/2

BRANCH STORES:
BROAD STREET,
ALRESFORD.
TEL.Nº 68.

HIGH STREET,
PETERSFIELD.
TEL.Nº 167.

DIRECTORS:
J. E. CHALCRAFT,
C. H. C. FLOOD,
A. E. KELSEY.

AEK.

TELEGRAMS AMEY, PETERSFIELD.
TELEPHONE Nº 38.

AMEY'S BREWERY LTD.,
~~THOMAS AMEY~~,
BREWER, WINE & SPIRIT MERCHANT.

Borough Brewery,
Petersfield.

Jan 2nd. 1951.

TRADE MARK.

The Secretary,
The Brewers' Society,
42, Portman Square,
London. W.1.

Dear Sir,

Requirements of Sulphur, Sulphuric
Acid and Sulphurous Acid.

Above: Alton Court Brewery Co. Ltd, Station Street, Ross on Wye. Founded 1846. Registered 1865. Acquired by the Stroud Brewery Co. Ltd in 1956 and was closed. Liquidated May 1961. Buildings now part of supermarket.

Below: Amey's Brewery Ltd, Borough Brewery, Frenchmen's Road, Petersfield. Founded by Thomas Amey in 1875, the brewery being built in 1883. Registered in 1946. Acquired by Whitbread & Co. Ltd in 1951 with twenty public houses and twelve off-licences, when brewing ceased. Some of the buildings are still standing.

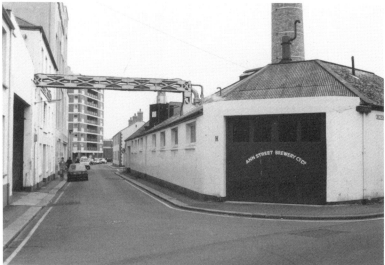

Ann Street
Brewery Co.
Ltd, 57 Ann
Street, St Helier,
Jersey. Known as
Bathe and Hole
in 1900 when
the partnership
was dissolved.
Registered 1905.
Also traded
as the Jersey
Brewery. Took
over the Tipsy
Toad in early
1997. Now owned
by Sandpiper
CI. Ceased
brewing in 2003
and site being
redeveloped.

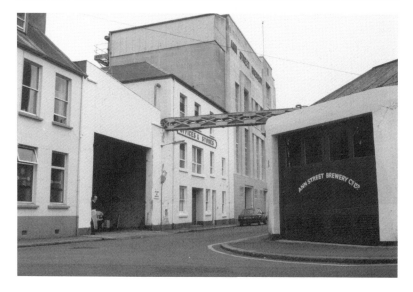

Alfred Bertwistle & Sons, Low Brewery, Doomgate, Appleby. Acquired by Marston, Thompson & Evershed Ltd on 15 August 1928. Used as a depot until the 1970s. Some buildings remain.

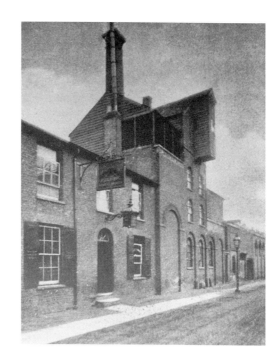

William Henry Apthorpe senior, Victoria Brewery, Albert (later Napier) Street, Cambridge. Brewery built by William Henry Apthorpe senior *c.* 1830. Leased to a series of brewers until bought by the Star Brewery (Cambridge) Ltd in 1891. Demolished in 1983.

Arnold, Perrett & Co. Ltd, High Street and Station Road, Wickwar. Listed in 1800 as Thomas Arnold, in 1876 Thomas Halsey became a partner, trading as Arnold & Halsey. A new brewery was built to replace 34 High Street. Registered June 1886 to acquire Arnold & Co. and E. & B. Trimmer of Gloucester as Arnold & Co. Ltd. The name changed in 1887 when H. & A. Perrett of Wotton-under-Edge was acquired with 325 tied houses. Forty public houses were sold to Bristol Brewery Georges & Co. Ltd in 1917. In 1918 John Arnold & Sons were selling a 12 qtr cast-iron mash tun, chilling plant and fifty-five barrel copper due to the disposal of the High Street brewery. Arnold, Perrett at Station Road was taken over by the Cheltenham Original Brewery Co. Ltd in 1924 and brewing ceased. Premises used as a cider factory until 1969/70. Arnold Brothers brewery on High Street was a separate concern taken over by George's. Buildings are extant.

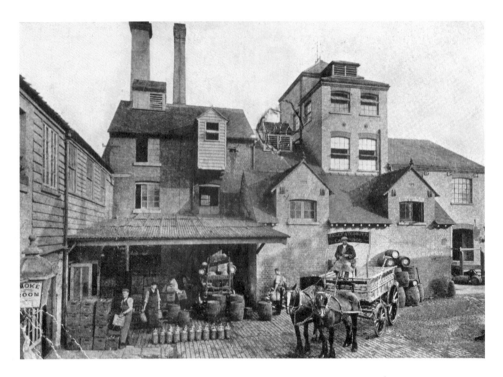

Above: Bailey & Tebbutt Ltd, Panton Brewery, 17a Panton Street, Cambridge. Founded in 1869 by Charles Lloyd Davis and was acquired by B. W. Beales in 1887. Became Bailey & Tebbutt in 1897. Private company registered in March 1918. Acquired by Greene King & Sons in 1925 with forty-eight houses. Brewing ceased in 1957 and the brewery was demolished in 1969.

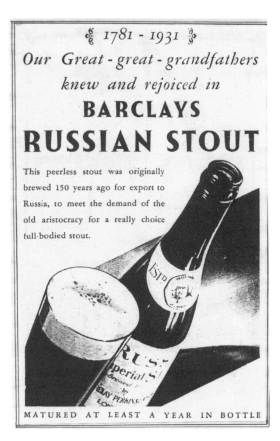

This page and opposite below: Barclay, Perkins & Co. Ltd, Anchor Brewery, Park Street SE1. Founded in 1616 by James Monger and became Barclay, Perkins in 1781. Registered in June 1896. Merged with Courage & Co. Ltd in 1955 to form Courage & Barclay Ltd. Brewing other than lager ceased in 1958 and the site was then rebuilt as a bottling plant. Lager brewing ceased in 1962/3, probably on the opening of the Harp plant at Alton and the Park Street site was later redeveloped. Anchor Terrace is a listed building and plaques have been erected in the area to record the history of the brewery.

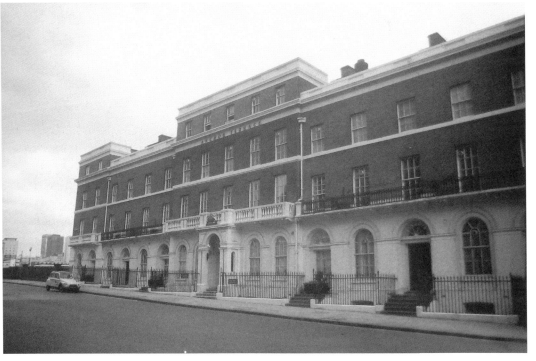

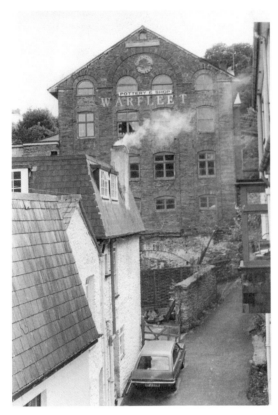

Left: Bartlett & Co, Warfleet Brewery, New Road, Dartmouth. John Maddocks bankrupt in 1884 and J. Bartlett selling mash tun by 1888. Acquired by the Heavitree Brewery Ltd 1926. Premises, originally a papermill, remain standing.

Below: Bentley & Shaw Ltd, Lockwood Brewery, Bridge Street, Huddersfield. Founded by Timothy Bentley in 1795. Two of his sons established the breweries at Rotherham and Woodlesford. Registered in October 1891. Acquired by Hammond's Bradford Brewery Co. Ltd in 1944 with 192 tied houses. Brewing ceased in 1962 but the maltings are still standing.

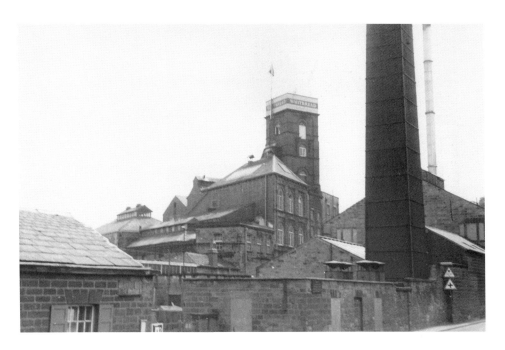

Bentley's Yorkshire Breweries Ltd, Eshaldwell Brewery, Woodlesford. Founded by Henry Bentley in 1828 as the Oulton Brewery. Registered in 1880 as Henry Bentley & Co. Ltd. Re-registered in 1892 as Henry Bentley & Co. and Yorkshire Breweries Ltd and the name was changed in March 1893. Acquired by Whitbread & Co. Ltd in 1968 with 380 houses and brewing ceased in October 1972. Site cleared *c.* 1989.

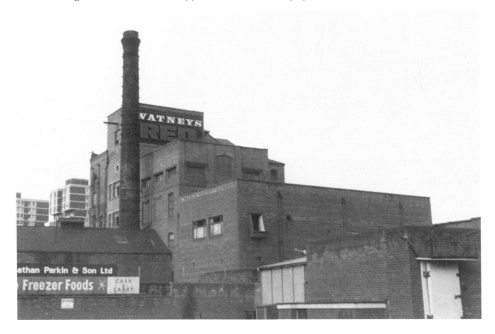

Beverley Brothers Ltd, Eagle Brewery, Harrison Street, Beverley. Founded in 1861. Registered in June 1888. Acquired by Watney Mann Ltd in March 1967 with 173 public houses and brewing ceased in October 1968.

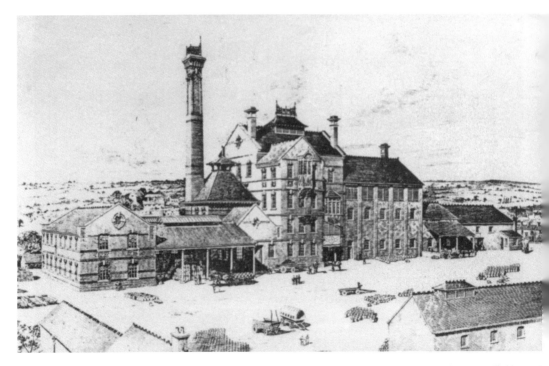

Wells & Winch Ltd, Church Street, Biggleswade. Founded by Samuel Wells in 1764. Registered in April 1899 to acquire Wells & Co. and 109 public houses. Acquired by Greene King & Sons in 1961 with 287 public houses. Closed in 1997 and brewery demolished.

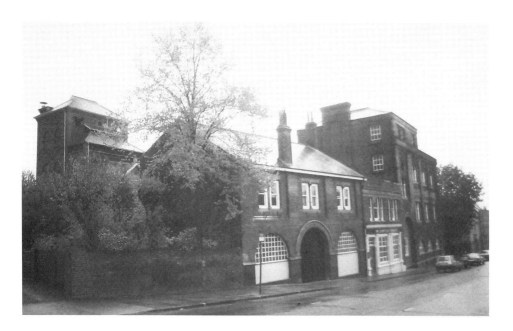

Colchester Brewing Co. Ltd, Eagle Brewery, East Hill, Colchester. Founded in 1828 by Christopher Stopes and Robert Hurnard. Christopher Stopes & Sons were acquired in January 1887 by the Norfolk & Suffolk Brewery Co. Ltd, who then changed their title in September 1887. Also at Langham until 1887. Acquired by Ind Coope Ltd in 1925 and was closed. Some of their 225 houses were sold to Lacon & Co. Ltd in 1926. Brewery still standing.

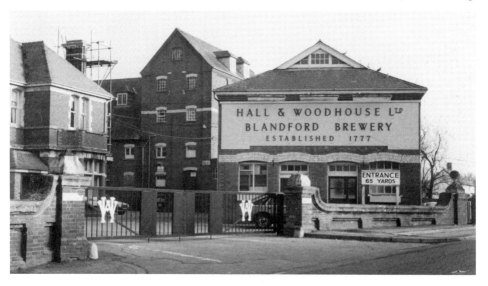

Above and next page above: Hall & Woodhouse Ltd, Badger Brewery, Blandford St Mary. Founded in 1777 at Ansty and acquired Neame & Trew (late John Hector) of Blandford St Mary in 1883 with twelve houses. Operated both sites until a new brewery was built in 1900. Registered on 8 June 1898 to acquire Hall & Woodhouse of Ansty and Blandford and Godwin Brothers, Durweston, with a total of 105 houses. Ansty brewery closed *c.* 1900. A new brewery has been built 300 metres across from the old one, which will be redeveloped. Still independent, trading as the Badger Brewery.

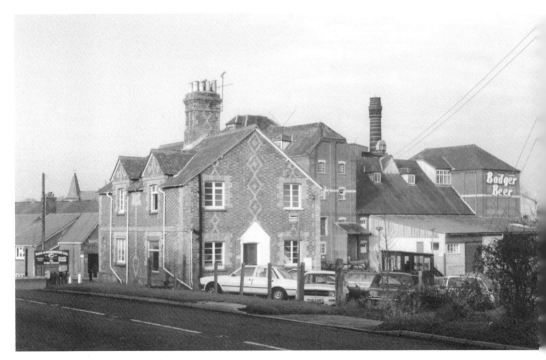

Blatch's Theale Brewery Ltd, High Street. Founded in 1752 and acquired by the Blatch family in 1854. Private company registered May in 1938. Acquired by Ind Coope (Oxford & West) Ltd in 1965 with twenty-two houses, and brewing ceased.

Edward Boniface, High Street, Cheam.
Merged with Thunder & Little Ltd
of Mitcham in 1898 to form the
Mitcham & Cheam Brewery Co. Ltd
and brewing ceased in 1911. Acquired
by Hoare & Co. Ltd in 1912.

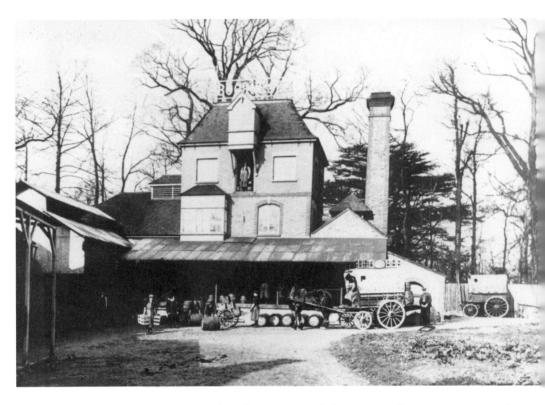

Above: Boorne & Co. Ltd, London Road, Wallington. Founded in *c.* 1810. Thomas Boorne joined as a partner with James Apted in 1830. Registered in July 1927. Acquired by Samuel Allsopp & Sons Ltd in 1931.

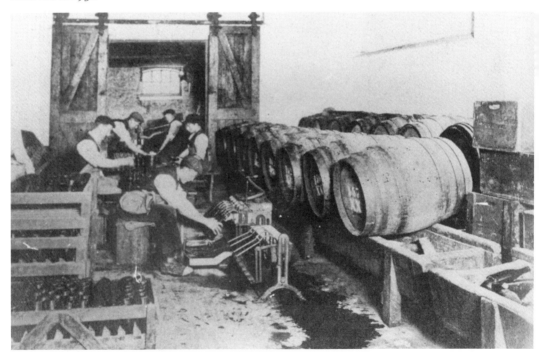

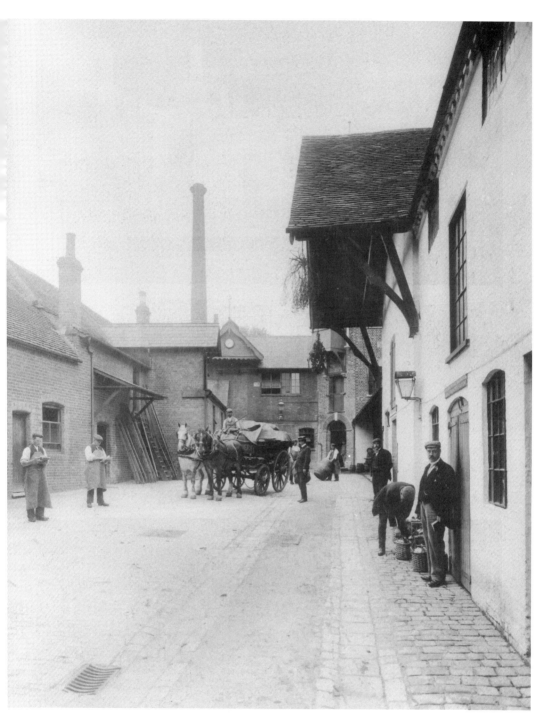

Above and opposite below: W. H. Brakspear & Sons Ltd, New Street. Founded by Richard Hayward at Bell Street and joined by Robert Brakspear in *c.* 1779. Merged with Appleton & Shaw, New Street Brewery, in 1812. All brewing was concentrated at New Street. Registered in January 1896. Ceased brewing in 2002. Some of the original brewing equipment is now in use at the Wychwood Brewery, Witney. Premises still standing.

J. C. & R. H. Palmer Ltd, Old Brewery, West Bay Road, Bridport. Founded in 1794. Private company registered in 1975. Still independent.

Burtonwood Brewery Co. (Forshaws) Ltd, Bold Lane, Burtonwood. Founded in 1867 by James and Jane Forshaw. Registered in 1910 as the Burtonwood Brewery Co. Ltd and was re-registered in April 1949. Owned by the Gilchrist side of the Forshaw family, who were also involved with Hook Norton. After an arrangement with Eldridge Pope they also brewed their beers as Thomas Hardy Brewers. The pub side of the business was acquired by Wolverhampton & Dudley in 2004.

John Emmerson, Caldbeck. In 1829, the brewery was converted from a cotton mill which had been built in 1671. Remains still standing.

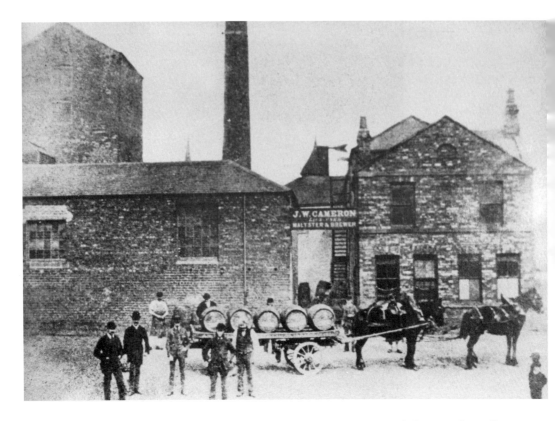

J. W. Cameron & Co. Ltd, Lion Brewery, Stockton Street, Hartlepool. Founded in 1852 by William Waldon. Leased to John William Cameron in 1872 with sixteen public houses, and he bought the brewery in 1893. Registered as above in November 1894 with fifty tied houses. Acquired with 750 houses in 1974 by Ellerman Lines Ltd, which in turn was acquired by Barclay Brothers in 1983 and finally sold to the Brent Walker Group in January 1989. It was then bought by Wolverhampton & Dudley in 2000. In 2002, they sold the brewery to Castle Eden but retained the Cameron's name.

Opposite page: Between 1914 and 1918, there were a number of munitions factories in the Carlisle area, and to control the drinking habits of the workers, all the breweries and public houses were brought under state control in 1916. The controlling body was the Carlisle & District State Management Scheme. It was announced in 1971 that the brewery and the 206 tied houses in the Carlisle/Gretna area would be sold to private enterprise. An attempt by Peter Lewis & Associates of Alston to recommence brewing as Lakeland Breweries was not realised and the brewery was sold to T. & R. Theakston Ltd of Masham, North Yorkshire for £90,000 in May 1974. It closed in 1987. Carlisle New Brewery Co. Ltd, Shaddongate. Originally registered in 1879 as the New Brewery (Carlisle) Ltd and re-registered as in 1899. Brought under state control in 1916 and was closed. Later used as maltings and sold to the Border Dairy Co. Ltd, Carlisle Old Brewery (Sir Richard Hodgson & Co. Ltd), Bridge Street. Founded in 1756. Used as the State Management brewery until 1973 and bought by Theakstons in 1974.

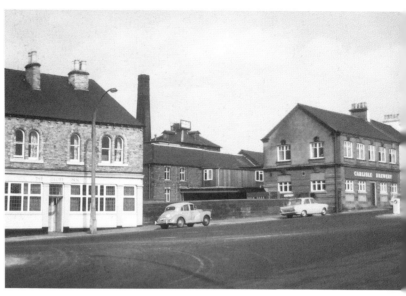

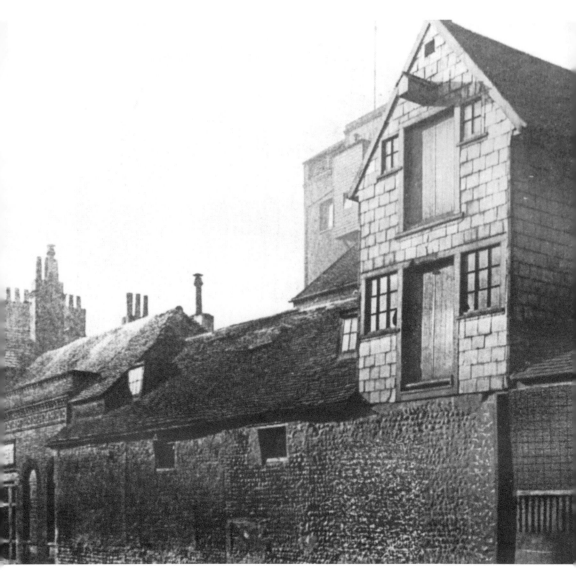

Chapman & Co., Black Lion Brewery, Black Lion Street. The brewery was built in 1733 by William Hicks. Acquired by the Rock Brewery (Brighton) Ltd in 1911 and later sold to Fremlins Ltd. Brewery demolished *c.* 1970.

Charrington, Nicholl &
Co. Ltd, East Hill Brewery,
Colchester. Founded in
1830 as a porter brewery.
Registered in 1904. Acquired
by the Colchester Brewing
Co. Ltd. in 1920. Brewery
demolished in 1971 but
offices remain.

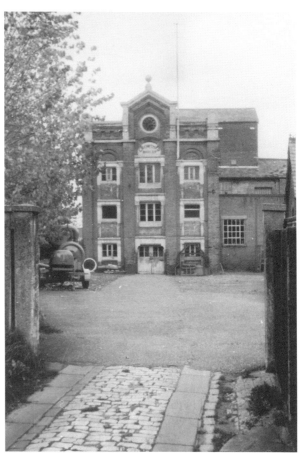

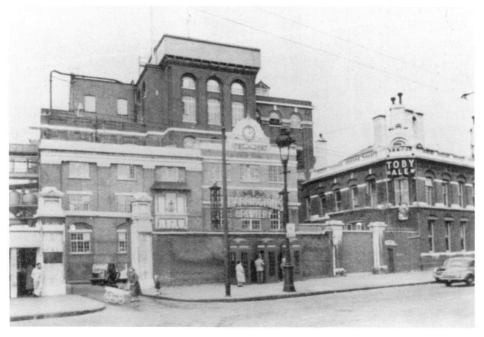

Above and previous page bottom: Chelsea Brewery Co. Ltd, 533 King's Road, Chelsea SW3. John Bowden founded the Royal Brewery in Fulham Road during the mid-nineteenth century. The business was moved to Chelsea in the 1880s and the brewery was renamed the Royal Chelsea Brewery. Registered in 1897 as the Chelsea Brewery Co. Ltd to acquire Bowden & Co. The company took over Smith's Welch Ale Brewery, Old Kent Road in 1900 and changed its name to the Welch Ale Brewery Ltd. Acquired by Watney, Combe, Reid & Co. Ltd with eighty houses in 1920. In 1924 converted into a wine and spirits department as the Cremorne Gate Cellars. Buildings remain as an antiques centre.

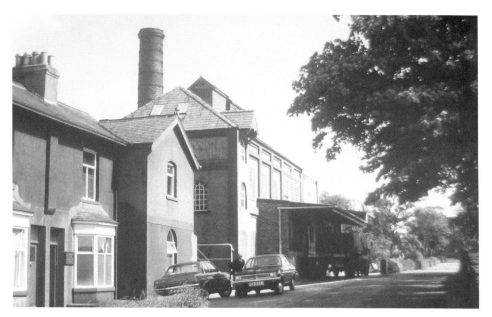

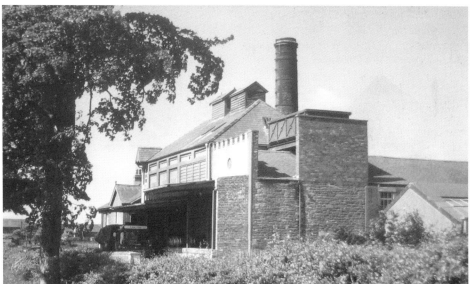

Above: Cleator Moor Brewery Co. Ltd, Birks Road, Cleator Moor. Registered in 1896 to acquire Paitson's Brewery Co. Ltd of Cleator Moor and William Foster Charter, Egremont. Acquired by Matthew Brown & Co. Ltd in 1947 with fifty houses. Brewing continued until at least 1954 but eventually was relegated to a depot.

Opposite below: West Country Breweries Ltd, 256 High Street, Cheltenham. Registered on 15 April 1888 as the Cheltenham Original Brewery Co. Ltd to acquire the business of J. T. Agg-Gardner, founded in 1760. Name changed to Cheltenham & Hereford Breweries Ltd in 1945 when the Hereford & Tredegar Brewery Ltd was acquired, and was later renamed again to Cheltenham Brewery Holdings Ltd. Merged with the Stroud Brewery Co. Ltd in 1958 to form West Country Breweries Ltd with 1,275 tied houses. Acquired by Whitbread & Co. Ltd in 1963 and was known as Whitbread Flowers Ltd. Closed in 1998 and demolished in 2004.

CHAPTER 4
Ale Becomes Beer

No doubt you will have already gathered that a number of key events in the development of the drink we enjoy today are shrouded in mystery, myth and confusion. So no surprises that the arrival and inclusion of hops in the final brew is also fairly vague. History shows it was used in earlier times as a way of warding off certain illnesses and it was one of many occasional ingredients used in ale prior to the Norman Conquest. There exists a not very useful pair of rhymes handed down to us that give some very conflicting information:

> Hops, Reformation, Bays and Beer
> Came into England all in one year

And,

> Hops and Turkey, Carp and Beer
> Came into England all in one Year

All in all hardly the sort of empirical evidence we historians like. So let's for the sake of the flow of my story say that hops in commercial volumes first began to be used in the fifteenth century. We know from documentary evidence that hops were growing in small commercial quantities in Britain by 1400 as a hopped beer was recorded in Winchlesea.

Whenever they actually arrived, hops were to have an impact on the brewing industry which changed it forever. As usual with all things new and foreign in Britain, hops were met with a great barrier of resistance. They divided the ale and beer drinkers into two camps. Soon there were two guilds: the Guild of Beer Brewers and the Guild of Ale Brewers. They even kept the measurements apart. During the siege of Rouen by Henry V in 1418, the food exported to the troops from England included both ale and beer as two separately listed items. Even Henry VIII in 1531 advised his own beer brewer not to use them in the king's ale.

Remote rural areas clung to their hopless ale well into the eighteenth century but its life was limited. In 1487 beer brewing, as opposed to ale brewing, was already well established and recorded in Canterbury.

Certainly in the 1570s a brewer in Essex was renowned for brewing ale with hops. In London in 1585 over 50 per cent of the beer brewers operating in the capital were from Europe, where the process of incorporating hops was more advanced. By the turn of the century most brewers in south-eastern rural areas at least were brewing beer and not ale. The inevitable tide of change moved north and eventually ale became a minority drink.

The adoption of hops as a major crop can be linked to the marriage of Edward III to Phillipa, daughter of William, Count of Holland and Hainault. Phillipa encouraged the

immigration to England of Flemish weavers to exploit England's rapidly expanding wool trade. The addition of hops had several advantages. It gave the brew longer keeping powers, thus allowing brewers to produce greater volumes and gain economies of scale. This one property, it could be said, kick-started the migration of domestic brewing to commercial brewing.

During the fourteenth and fifteenth centuries, brewers experimented with various additives to improve flavour and, more importantly, extend the shelf life of their beers. At some point in these 200 years they all seemed to settle on the hops as being the ideal additive. Effectively they had turned ale into beer.

The hop is a member of the cannabis family and may well have been introduced into England during the Roman occupation. Pliny, the Roman documenter, mentions them in his book *Natural History* as a garden plant whose young shoots were eaten as a salad. It has been used in medicines for its calming effect.

Until the nineteenth century, there were many different varieties of hops. In 1790 a Mr Golding found a particularly good variety growing in his hop garden. These were then used in brewing from 1796 and since then they have become one of the major strains of hop used in brewing. In 1861, in Horsmonden in Kent, experiments by local growers resulted in the development of Fuggles, the other major brewing strain. Until recent new and imported varieties have become available, these were the main stays of hops for the brewing industry.

However, it enters our story for its flavour and keeping properties. As the hops grew 'like a wolf among sheep', it gave rise to the Roman name *lupus salictarius*. This became *humulus lupulus* when it received its Latin botanical name. Records in Babylon refer to a cure for leprosy which was *ex lupulis confectam* ('made from hops'). In the eighth and ninth centuries, gardens in Bohemia were reported to have hops in them but not necessarily for brewing purposes.

It was in the sixteenth century that the battle between ale and beer reached a climax. In 1542, social commentator Andrew Boorde drew a line in the sand when he stated: 'Beer is fine in its place, it is just that its place is not England'. He also expounded: 'Ale for an English man is a natural drink', 'Beer ... is the natural drink for a Dutch man.' As late as 1651 the Water Poet recorded that 'beer is a Dutch boorish liquor, a thing not known of in England till of late days, an alien to our nation, till such times as hops and heresies come among us, it is a saucy intruder in the land.'

The battle lines were drawn and the protagonists peered at each other over steaming guns. Was this merely sabre rattling or thermometer rattling?

CHAPTER 5
The Golden Age

All during the fifteenth and sixteenth centuries the young upstart beer began to overtake its aged cousin. An early reference to beer by name was made in 1492, when John Merchant of the Red Lion Brewery in London was given a permit by Henry VII to export '50 tuns of ale called Berre'. Don't forget this name as the Red Lion was to make another important entry into our story a little later.

In 1591, that eminent observer of Tudor England, John Stow, recorded over twenty London Thameside brewers exporting beer abroad. Combined the export was of 26,400 barrels, or 7.5m pints, hardly small beer but huge given the limitations of the Elizabethan world. Contrary to the urban myths that continue today (and without which the entertainment value of QI would be much diminished) no brewer took their water from the Trent, the Thames or the Liffey. They all spent considerable sums sinking well complexes within their premises, making sure that the water they pumped out of them was cleaner and purer than anything the communal open sewers, that were the rivers of the time, could provide. The local geology added salts of varying chemical compounds to this well water creating the truly local beer. The flavour and the properties of so many beers were dependent on the geology of the local subsoil. As the brewers began to understand the scientific process that was involved in their industry, water began to be tampered with. Many brewers not connected with the Burton area, began a process of adjustment to their water in a process eventually called 'Burtonisation'. Even the brewers of Burton began to 'Burtonise' their beers – coals to Newcastle no doubt. One thing the sinking of a well to guarantee water purity did was to guarantee large capital expenditure. Add this to the storage of the product over long periods and the need for capital can be clear. Large fortunes were made but large fortunes were also needed just to keep the beer flowing.

At the dawn of the seventeenth century, the earliest shoots of large-scale commercial brewing were emerging. One unlikely stimulator was Charles I, who in 1635 decided to raise some much needed cash by taxing malt. Given the huge number of beerhouses that existed in densely populated cities and towns, collection of the tax was almost impossible. So to make matters easier, the authorities decided to restrict brewing in beerhouses in towns, forcing them to buy in from common brewers. Inadvertently, it made the common brewers seek economies of scale as demand in the towns rose. This kick-started the beer production model still used today and provided the Treasury with a nice little earner, thank you very much. In 1690 Parliament attempted to restrict all brewing to common brewers only.

It was becoming clear that the brewers of London and other major conurbations were seeing opportunities to expand beyond their own brewhouses and brew for a wider market. Academics might argue that the black stuff dug out of the coal pits of the Midlands and Northern England fueled the Industrial Revolution. My argument is that it was black stuff

but it didn't come from a colliery, it comes from a simple question: 'How did those workers, toiling in unimaginable heat and dirt and dust, quench their thirsts?'. Certainly, beer was their drink of choice and Porter was the top product. So imagine if you will, men coming out of the pits, the foundries, the manufactories and the docks, having done a day's work that involved sheer muscular expenditure, seeking rehydration. No fancy energy drinks for them. No reaching for bottled water or tap water either. It was straight into the nearest beer or alehouse. This lubricated the Industrial Revolution, this provided the refreshment for the men that made the modern world. Without beer, whether that be Porter or Mild or any other beer style available, the Industrial Age would have stalled, even failed!

Interestingly, it wasn't just those who worked in the heat and dust of newly industrial Britain that were fueled by beer. Thomas Cubbitt, the engineer and developer who worked on some of the posher parts of London's West End, made sure that the servants of the monied classes for whom he was building his mansions, could also slake their thirsts. He built several public houses in odd corners of the rapidly spreading area of Belgravia and Mayfair, such as The Star and around the corner, The Grenadier. Admittedly, other posh enclaves sought to keep the dreaded drink at bay by banning pubs.

It is no coincidence that the huge brewing firms that are only just beginning to fade from the twenty-first century collective consciousness were all formed during this time. At the start of the eighteenth century some of the names we still recognize as brewers began to found their dynasties. Names such as Watney, Whitbread, Courage, Guinness, Bass and Truman.

As the Industrial Revolution began, people started to move into cities in even greater numbers. The city as an entity had existed for many centuries but things had been gaining speed as the need for workers moved the labour force from the field to the blossoming factories. This created large markets for produce of all sorts and the brewers of London, Manchester, Edinburgh and Dublin were quick to see the opportunities this created.

They all capitalised on previous brewing knowledge and the demands of the thirsty workers. Brewers of these metropolises benefited from a large market close by and avoided the problems of transportation. A horse-drawn dray could service numerous local outlets on roads which were slowly becoming more easily navigated than their country cousins. Brewing began to produce wealthy families. For example in the 1810s James Walsh, the owner of the Imperial Brewery, Battersea, had a turnover of £246,250 and made an annual profit of £20,691.

The common brewers at this point were creating wealth for themselves, and their families, and began embarking on public-spirited adventures. They were elected as MPs, city aldermen and collected knighthoods. As one wit in 1714 stated:

Brewers have from tuns and coolers
Arose to be our sovereign rulers
and still to their immortal praise
build coaches daily out of drays.

In a review called 'Some Account of London' dated 1786 and undertaken by Thomas Pennant, he lists the twenty-four largest brewers. Most of the top ten are names familiar to beer drinkers of recent times. Truman, Whitbread, Courage, Charrington, Mann and Watney. Annual output was also listed, ranging from a mere 10,000 barrels to a whopping 150,000. Between them the total output for 1786 was a staggering 5 million barrels, much for export.

These famous and familiar names in the brewing industry owe their existence and their significant family fortunes to just one beer style – Porter. This influential beer style emerged from the turmoil of the early industrial age as the key product of the expanding brewers. They capitilsed on the fluctuating price of malt by buying at its lowest, brewing with it and storing the resultant brew. As they were adding huge amounts of hops to the mix its keeping properties were greatly extended. Larger and larger vats were used to keep the brews, often up to a year, often longer. This brew was originally called butt beer, then entire butt and finally Porter, nicknamed after the porters prevalent in London.

Today we see many Porters available from the multitude of brewers but once it was almost the only beer you could get. It started way back in the rein of Queen Anne as a natural development of the muddy brown beer that all brewers brewed. The history of this particular beer, like that of the aleconner, is surrounded in myth and legend. A modern-day champion of the truth, Martyn Cornell, has spent many a long hour researching the real history of the development of Porter. Casting aside the flamboyant urban myths, he believes that it simply grew out of a need to brew a beer that utilised the hops and malts that were being developed at the time. Certainly it was a beer that kept well, satisfying the brewers' need to have a stable product that did not go off quickly. Of course this also benefited the publicans of the time, allowing them to keep serving rather than swap out barrels as they went 'off'. It required the brewers to build larger and larger vats allowing maturation of considerable periods, often as much as eighteen months. This forced them to find more and more locations to keep the beer. Whitbread used vast underground storage cellars, whilst others just rented space elsewhere.

If one was forced to ask 'Who invented Porter?' then probably the brewery that can be reliably referred to as the place that Porter began is the Red Lion Brewery, East Smithfield, remember them from before? They, under the inspiration of then owner Humphrey Parsons, began the trend for larger and larger vats and manipulating brewing periods to benefit from the varying costs of materials.

By 1736 Porter was described as the 'best strong beer in London'.

The emerging Porter breweries of Barclays Perkins, Whitbread, Trumans, Courage, Meux, all vied with each other to be number one. They would use their breweries to try out the latest that technology could offer. From 1740 onward it was fashionable to use larger and larger vats to store the Porter in. For example Meux of the Horseshoe Brewery in Tottenham Court Road, installed twenty-four vats with a capacity of 8.4 million pints. One of these alone held 1.296 million pints. To regain the number one position, in 1795 Meux built themselves a vat, imaginatively called The Great Vat, holding 5.76 million pints. It was 30 feet deep and 70 feet high and was bound by hoops of iron each weighing 3 tons and costing £300 each. The structure cost over £10,000. The success of this giant led to more monsters being built. At

one time, a banquet was held for 200 people inside the actual vat itself. They were often lent out to the nobility of the City as a novel dining place. However, when pushing the bounds of technology sometimes things do not happen the way you planned them. In November 1814 the inevitable happened at Meux's Brewery. The bottom hoops of a full vat of Porter slipped. Weighing over one ton it was only just holding its own against gravity, but once gone the remaining hoops had no chance. The rest, pushed out by the vast quantity of maturing Porter, burst like poppers on a raincoat. The resulting tsunami of beer crashed thought the brewery, knocking down walls and sweeping into the street. Eight people drowned.

Porter may have rapidly gained a huge following in the capital, but around the start of the eighteenth century, provincial beers had already begun to arrive in the capital. A book published in the 1720s records over twenty-three different types of provincial beers being sold in London. Beers from Dorchester, Derby, Yorkshire, Doncaster, Nottingham, Lichfield and of course Burton upon Trent. Samuel Pepys notes his preferred beers being Margate Ales, Northdown ales and Lambeth ales. It is true to say the recipe for Porter did travel northwards. Sheffield opened a Porter brewery in 1744 and Dublin and Glasgow in 1759 and 1775 respectively.

Despite being a capital intensive product, it was very, very profitable. In the period 1730 to 1750 Ralph Thrale, a predecessor to the Barclay Perkins Brewery in London who eventually became Courage, doubled the capital valuation on his brewery. In 1747 *The London Tradesman* magazine reported that more capital was needed to set up as a Porter brewer than to open as a banker. In fact there is a close link between the two, and often the offspring of a successful brewer became a successful banker.

During the latter half of the eighteenth century, exports of beer to the emerging markets of Europe, Africa, America, the West Indies and Asia were increasing. One of the largest was the Baltic region whose population had developed a taste for English-style beers. The brewers of Burton up on Trent were quick to exploit this demand. Burton was the birthplace of a number of influential commercial brewers. Samuel Allsopp began his brewing career there, later the company to merge with Ind Coope which eventually became Allied Breweries. In 1777 one William Bass, a common carrier from Burton on Trent, bought himself a brewery and began to sell beer. By 1802 he was faced with a difficult decision. Both businesses were doing well but he was not able to split himself easily between the two, one would have to go! So he sold his removals firm. The advert was seen and responded to by one Thomas Pickford. Both men went on to make successes of their respective trades.

However, it was a brewer called Hodgson from London who helped open up a great trade route to India with a special type of light beer which acquired the name India Pale Ale, or IPA.

The expansion of brewing within the British Isles and the drive for sales, efficiency and quality resulted in endless experimentation with brewing and fermenting methods. There was the Stone Square – often referred to as the Yorkshire Square System, no surprise that this was mainly used in Yorkshire, plus parts of Lancashire and Nottinghamshire. The invention has been attributed to Timothy Bentley. In Burton, the canny brewers developed the Burton Union System of fermentation which just about survives today in the custody of Marstons of Burton.

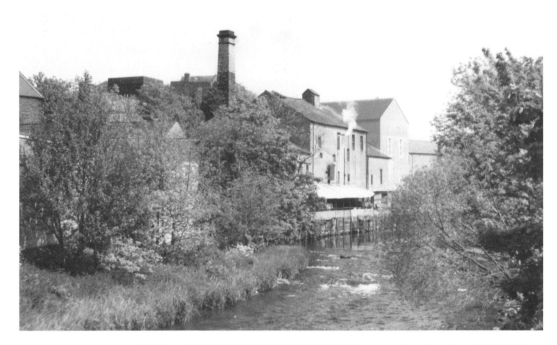

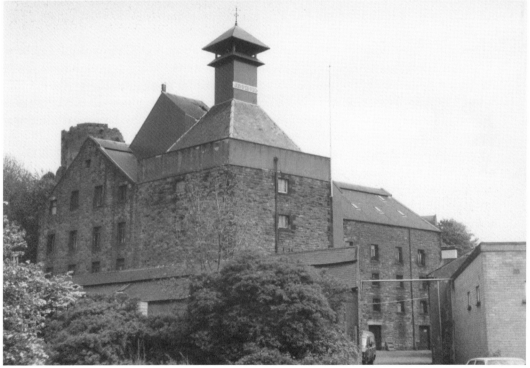

This and opposite page: Jennings Brothers Ltd, Castle Brewery, Castlegate, Cockermouth. Founded at Lorton in 1828 and concentrated at Cockermouth by 1887 following the purchase of Wyndham's brewery. Public company registered in 1887, with forty-one tied houses. Purchased by Wolverhampton & Dudley in 2005 and still brewing.

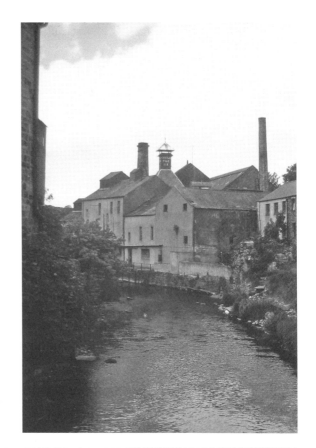

Copple Brothers, Portico Lane, Eccleston, Merseyside. Founded by 1871. In 1906 they had at least six public houses. These were bought by Greenall Whitley *c.* 1927, but it is believed that they continued to supply the domestic trade until at least 1939.

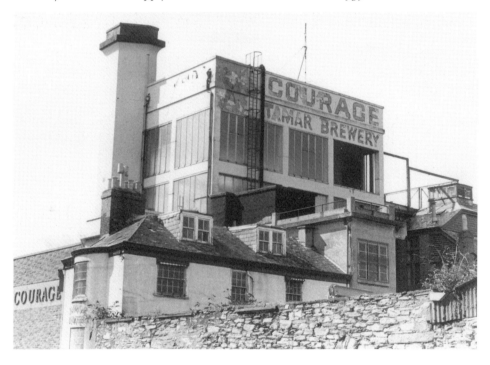

G. Crake, Tamar Brewery, 12 Tamar Street, Devonport, Plymouth. Founded by 1820. Acquired by H. & G. Simonds Ltd in 1919 with about twenty-eight tied houses. Brewing ceased in 1975 and some of the equipment was used by the Blackawton Brewery.

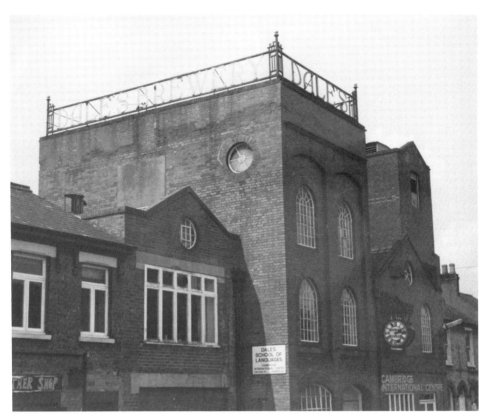

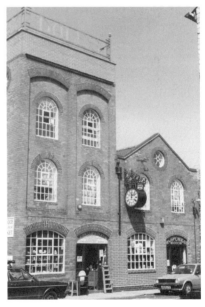

Dale & Co. Ltd, Gwydir Street, Cambridge. Founded by Frederick Dale at the British Queen, Histon Road in 1898 and the Gwydir Street brewery was built in 1902. Acquired by Whitbread and Co. Ltd in 1954 and brewing ceased in 1958. Some of the brewery buildings are still standing as an antiques centre.

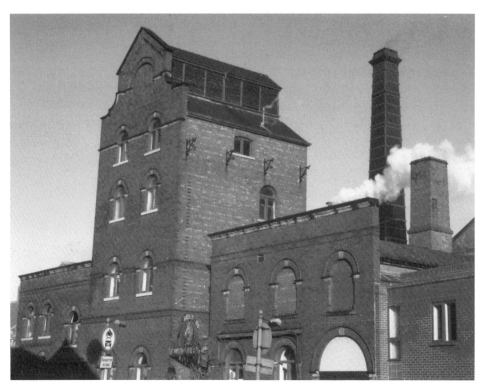

W. M. Darley Ltd, King Street, Thorne. Founded by 1837. Registered in 1918 and reconstructed in 1927. Acquired by Vaux in 1978 with eighty-eight houses. The brewery closed in September 1986 but some of it remains in a supermarket complex.

In the 1960s and 1970s, whether you liked them or hated them, national beer brands were everywhere. The volumes that moved from brewery to bottling plant to depot were quite huge.

Devenish Weymouth Brewery Ltd, Hope Square, Weymouth & Redruth, Cornwall. Founded in 1742 by the Fowler family and acquired by William Devenish in 1824. Registered in 1889 as J. A. Devenish & Co. Ltd and the name was changed in 1965. 330 tied houses. Brewing ceased at Weymouth in November 1985 and was concentrated at Redruth as the Redruth Brewery (1742) Ltd. Houses acquired by Greenalls in 1993.

William Ingram Drake, Duke Street (now Prior's Hill), Kingsclere. Founded in 1790. William Drake listed in 1830. Acquired by John May & Co. Ltd. of Basingstoke 1921. The buildings are still standing.

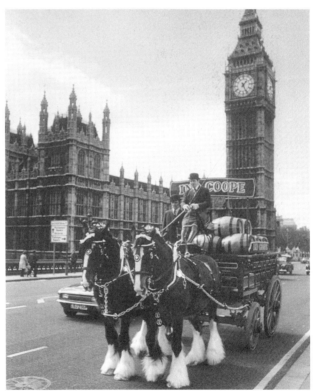

Right and next page above: Ind Coope Ltd, Star Brewery, Romford. Founded in 1708 at the Star Inn by George Cardon. In 1799, Star Inn and brewery was purchased by Edward Ind and J. Grosvenor. C. E. Coope joined the firm in 1845. Registered in November 1886 as Ind Coope & Co. Ltd. In receivership in January 1909 and re-registered in 1912 as Ind Coope & Co. (1912) Ltd. Name reverted to Ind Coope & Co. Ltd in 1923. Merged with Samuel Allsopp & Sons Ltd in 1934 and became Ind Coope & Allsopp Ltd. Name changed in 1959. Later part of Carlsberg-Tetley and eventually closed in 1992. Now a shopping mall.

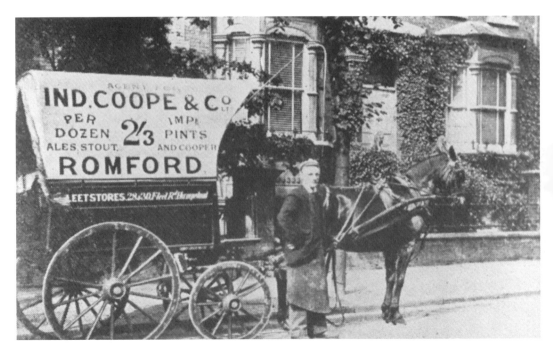

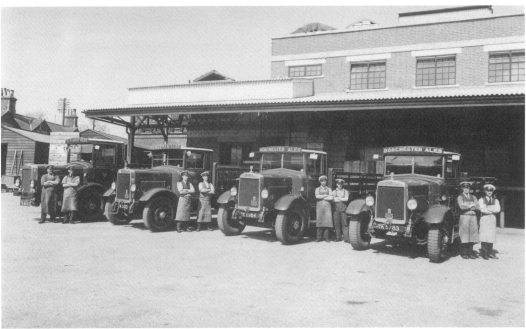

Eldridge, Pope & Co. Ltd, Dorchester Brewery, Weymouth Avenue, Dorchester. Founded in 1837 when Charles Eldridge leased the Dragon Brewery, Ackland Road/Durngate Street (closed in 1883). Dorchester Brewery opened in 1880. Registered in May 1897 with seventy-four public houses. Pub estate separated from brewing in 1996 and management buy-out followed in 1997. This merged with Burtonwood in 1998 as Thomas Hardy Burtonwood. Pub estate sold to Michael Cannon in 2004, who then sold it to Marstons in 2006. Brewery still standing and is in use residentially.

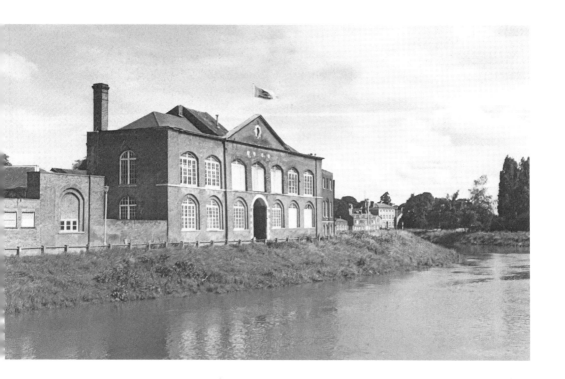

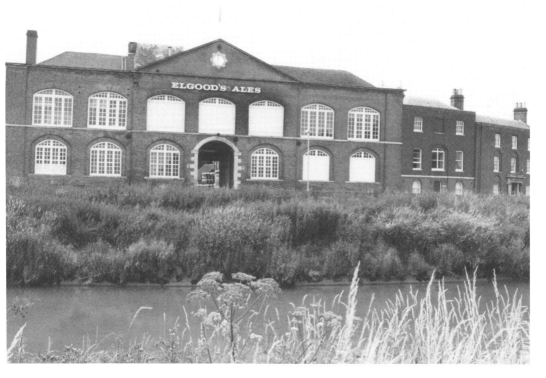

This and next page: Elgood & Sons Ltd, North Brink Brewery, Wisbech. Founded in 1795. Registered in 1905. Still brewing independently.

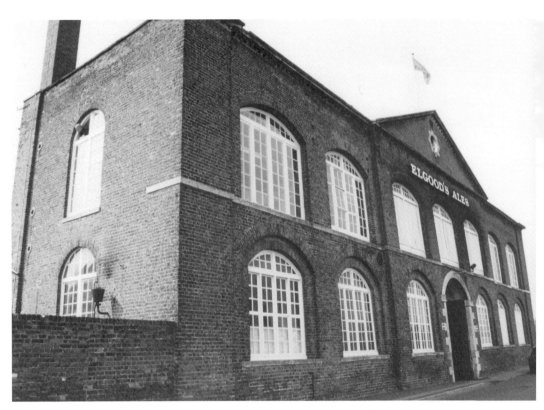

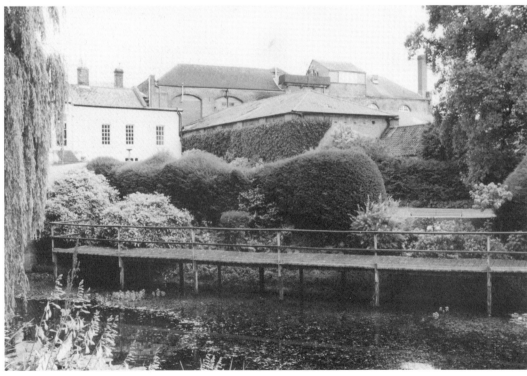

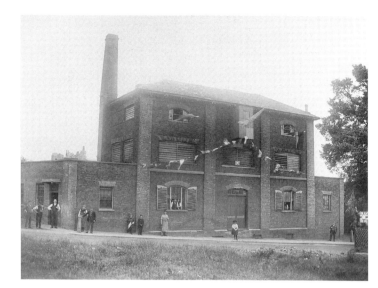

Fielder & Co., King's Road, Brentwood. Founded by 1855. Acquired by S. R. Conron & Co. of Hornchurch in 1923. Buildings still standing.

Flower & Sons Ltd, Brewery Street, Stratford-upon-Avon. Founded by Edward Fordham Flower in 1831. New brewery built in Birmingham Road in 1874. Registered in February 1888. Acquired by J. W. Green Ltd of Luton in 1954, who then changed their name to Flowers Breweries Ltd. The brewery was closed in 1968 when Whitbread merged Flowers with West Country Breweries to form Whitbread Flowers Ltd. Brewery demolished.

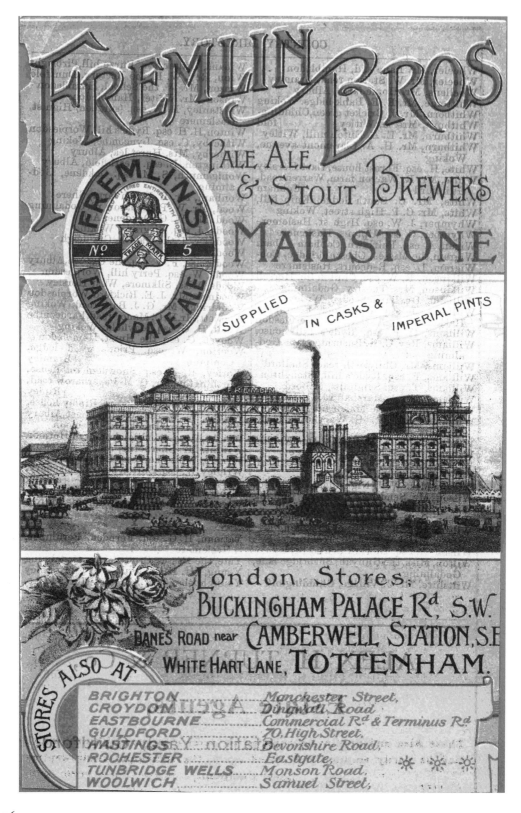

FREMLIN BROS

PALE ALE & STOUT BREWERS

MAIDSTONE

FREMLIN'S FAMILY PALE ALE No 5

SUPPLIED IN CASKS & IMPERIAL PINTS

London Stores,
BUCKINGHAM PALACE Rᵈ, S.W.
DANES ROAD near CAMBERWELL STATION, S.E.
WHITE HART LANE, TOTTENHAM.

STORES ALSO AT

BRIGHTON	Manchester Street,
CROYDON	Dingwall Road,
EASTBOURNE	Commercial Rᵈ & Terminus Rᵈ,
GUILDFORD	70, High Street,
HASTINGS	Devonshire Road,
ROCHESTER	Eastgate,
TUNBRIDGE WELLS	Monson Road,
WOOLWICH	Samuel Street,

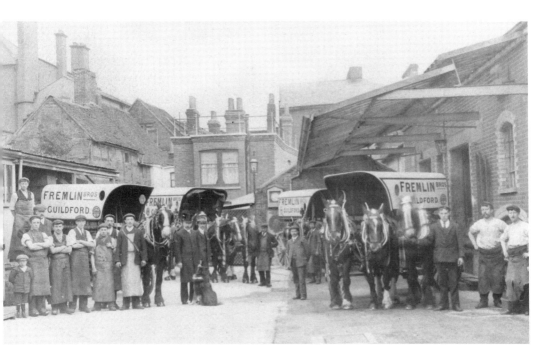

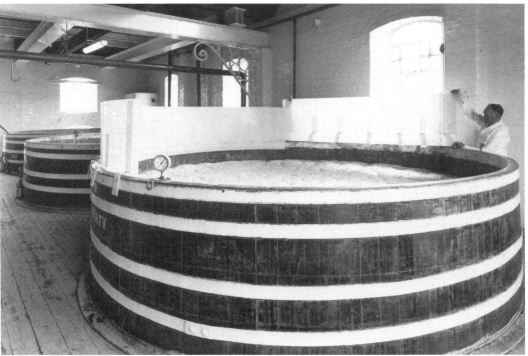

This and opposite page: Fremlins Ltd, Pale Ale Brewery, Earl Street, Maidstone. Founded in *c.* 1790. Acquired by Ralph Fremlin from the executors of John Heathorn in 1861. Registered as Fremlin Brothers Ltd, a private company, in 1920 and as above in 1928. Acquired by Whitbread & Co. Ltd in 1967 with 714 public houses. Brewery closed in October 1972 but used as a depot until 2003, when it was redeveloped as the Fremlins Centre.

Right and opposite: A & T Sibeth, Crown Brewery. Founded in 1780. Before it was acquired by Sibeth, it was occupied by the Flower family, an important brewing dynasty. Ceased brewing on 14 December 1904 and was sold with twenty-one public houses for £25,410, the houses being sold piecemeal to a total of eight local brewers, including Hall & Woodhouse Ltd, Baxter & Sons and Marston's Dolphin Brewery Ltd. Still standing among reproduction properties.

Below: John Furze & Co., St George's Brewery, Whitechapel, E1. Acquired by Taylor, Walker & Co. Ltd in 1901 and closed. Premises became depot of Johnny Walker of Kilmarnock until at least 1949. Buildings still standing.

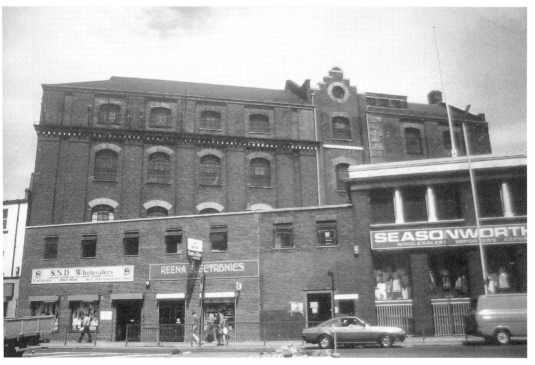

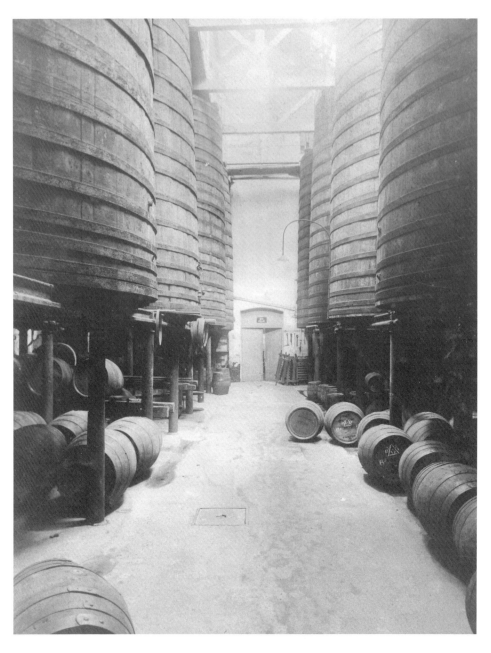

During the eighteenth and nineteenth centuries, maturing beer took up more and more room on the brewery shop floor.

Opposite: Gardner & Co. Ltd, Ash Brewery, Sandwich Road. Founded in 1837 when George or Thomas Bushell converted the parish workhouse into a brewery. Acquired by William Gardner in 1840 with forty-nine tied houses. Traded as Gardner & Godden from 1858. Registered in 1898. Amalgamated with Tomson & Wotton Ltd of Ramsgate in 1951 to form Combined Breweries (Holdings) Ltd, which was acquired by Whitbread & Co. Ltd in June 1968. Brewing ceased at Ash in 1954, although ginger beer production continued until 1962. Brewhouse demolished but traces remain.

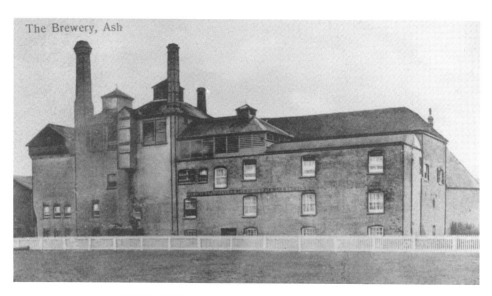

The Brewery, Ash

GARDNER, GODDEN & Cᵒˢ

EAST INDIA PALE AND STRONG ALES

ASH BREWERY NEAR SANDWICH KENT.

LONDON AGENTS
MESSʳˢ DELMAR BROˢ 63½ KING WILLIAM Sᵀ. CITY.

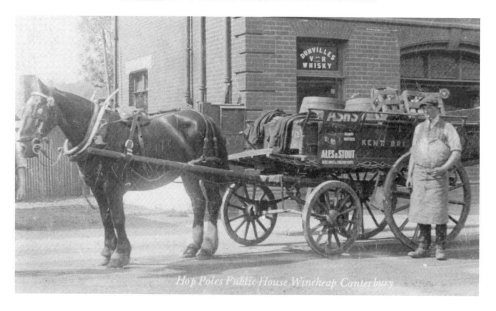

Hop Poles Public House, Wincheap, Canterbury

Above: E. Gardner & Son, Little Coggeshall Brewery, Bridge Street, Coggeshall. Founded in the eighteenth century by Henry Skingley and sold to Gardner. Leased to Greene King & Sons in January 1941 with seven public houses and closed in 1943. The adjacent pub, the Porto Bello, was formerly the Bell and dates from *c.* 1750. Both brewery and pub are still standing as private residences.

Next two pages: Bristol Brewery Georges & Co. Ltd, Old Porter Brewery, Bath Street, Bristol. Founded *c.* 1730. Registered in February 1888. Acquired by Courage, Barclay & Simonds in 1961 with 1,459 tied houses. Brewery closed in 1999. Buildings remain as new development.

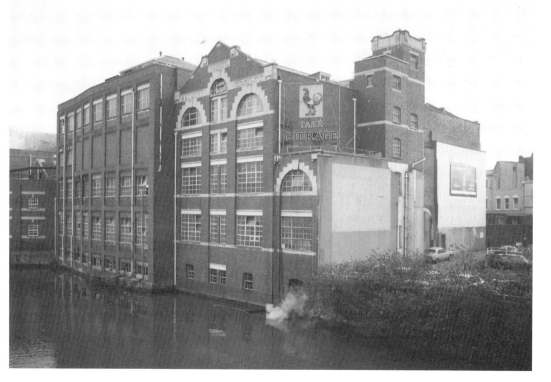

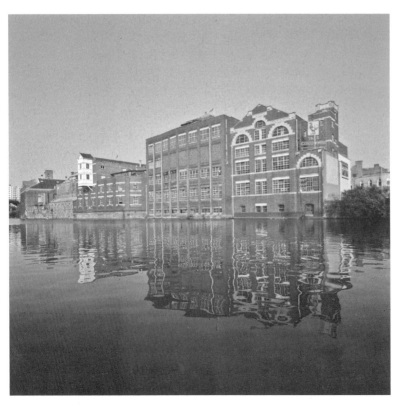

Above: William Glossop & Bulay Ltd, Globe Brewery, Northumberland Avenue, Hull. Registered in 1898 as William Glossop Ltd. Acquired by the Hull Brewery Co. Ltd in 1920 with fourteen houses. Company continued as maltsters.

Below: Lion Brewery Co. Ltd, Lion Brewery, Belvedere Road, Lambeth SE1. Originally known as Goding's Brewery. Registered in April 1865. Acquired by Hoare & Co. Ltd in 1923 and then closed. In 1929 the London County Council offered the brewery to the Southern Railway as the site for a new terminus on the condition that they gave up Charing Cross station, but this scheme was shelved in 1931. Brewery demolished in 1949 to clear the site for the building of the Royal Festival Hall.

Godwin Brothers Ltd, Belmont Brewery, Devizes Road, Swindon. Registered October 1907. Acquired by Wadworth & Co. with six houses in 1938 and brewing ceased. Two houses then resold to Ushers. Some buildings remain.

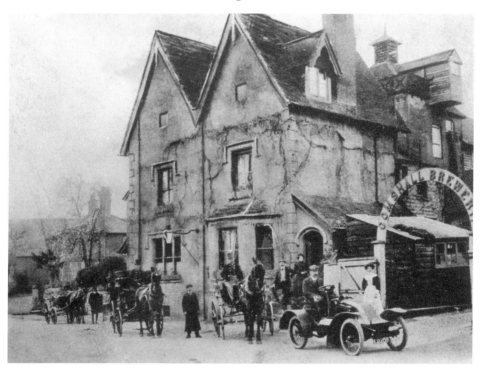

Reffell Brothers, Black Horse Brewery, Gomshall, Surrey. Offered for auction on 23 March 1926 with three tied houses, two of which were bought by Young & Co.'s Brewery Ltd of Wandsworth, London.

Gray & Sons (Brewers) Ltd, Springfield Road, Chelmsford & Gate Street, Maldon. Founded in 1828 by Charles Stanton Gray. Maldon brewery acquired *c.* 1896 and ceased brewing in 1952. Registered in 1957. Name changed to Gray & Sons (Chelmsford) Ltd in 1973. The Chelmsford brewery closed in September 1974 and their forty-nine public houses are now supplied by Greene King & Sons. Brewery buildings remain.

Seabrooke & Sons Ltd, Thorrock Brewery, Bridge Street, Grays. Founded in 1799 by Thomas Seabrooke. Registered in 1891. Acquired by Charrington & Co. Ltd in 1929 with 120 public houses and brewing ceased. Brewery demolished in 1969.

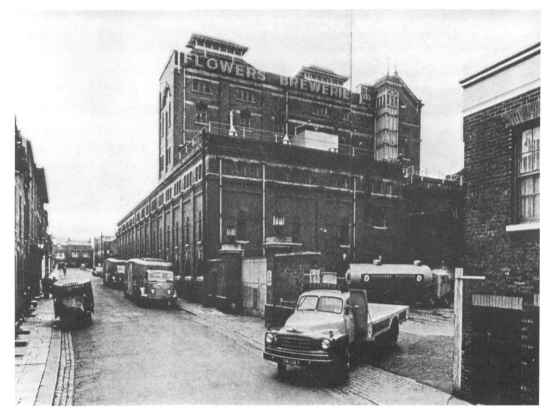

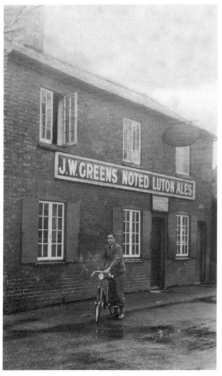

Flower's Breweries Ltd, Phoenix Brewery, Park Street West, Luton. Founded by Henry and Frederick Pearman in 1857 and sold to J. W. Green in 1869. Registered in September 1897 as J. W. Green Ltd. The name was changed in 1954 when Flower & Sons Ltd of Stratford-upon-Avon were acquired. Acquired by Whitbread & Co. Ltd in 1961. The Phoenix Brewery was closed in 1969 when Whitbread's giant new brewery in Oakley Road, Luton, was opened. This in turn being closed in 1984. However, a test plant may still having been brewing at Park Street in the 1990s. Offices remain.

Opposite above: Arthur Guinness, Son & Co. Ltd, St James's Gate, Dublin. Founded in 1759. Registered in October 1886. Park Royal Brewery, London opened in 1936. Became part of Diageo. In 2008 they announced that brewing will transfer to a new brewery within Dublin and part of St James' Gate will be redeveloped.

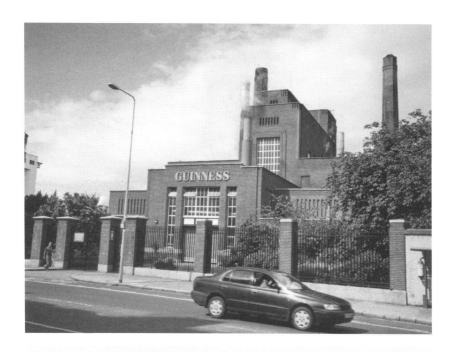

Arthur & Bertram Hall Ltd, Forehill Brewery, Forehill, Ely, Cambridgeshire. Hall family believed to have brewed on the Quayside in the years 1700–50. Forehill Brewery built 1869–71. Registered 1912. Merged with Cutlack & Harlock Ltd in September 1930 to form Hall, Cutlack & Harlock Ltd, which merged with Huntingdon Breweries Ltd in June 1950 to form East Anglian Breweries Ltd. These were acquired by Steward & Patteson Ltd in 1957. Forehill Brewery closed in early 1969.

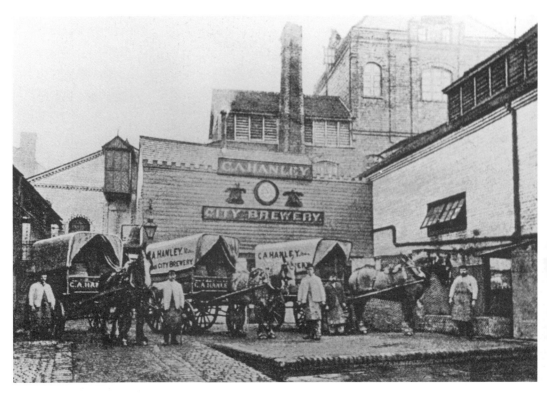

Above: Hanley & Co. Ltd, City Brewery,
20 Queen Street. Founded in the 1840s.
Registered in April 1890. Acquired by
Hall's Oxford Brewery Ltd with 100
public houses in 1898, who concentrated
production there until 1925, then sold it to
the corporation in 1928. Brewery now the
Museum of Modern Art.

Left: John Dalzell, High Street, Harrington.
Founded in 1847 by John Dalzell. In 1892
Thomas Dalzell merged with Joseph
Dalzell of Parton. Brewery closed prior to
1925 and seventy-five houses acquired by
the Workington Brewery Co.

This and next page: Hartleys (Ulverston) Ltd, Old Brewery, Brewery Street. Founded in *c.* 1755. Private company registered in October 1918. Acquired by Frederic Robinson Ltd of Stockport in 1982 with fifty-four tied houses. Ceased brewing in 1991.

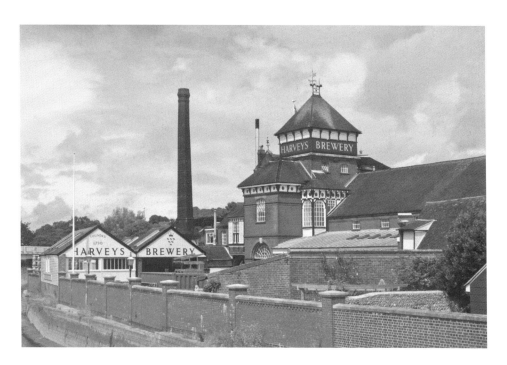

Harvey & Son (Lewes) Ltd, Bridge Wharf Brewery, 6 Cliffe High Street. Established in 1790. John Harvey bought Bridge Wharf and erected a brewhouse there in 1839. Registered in November 1928. Still brewing independently.

Heavitree Brewery Ltd, 16 Church Street, Heavitree. Founded in 1790. Registered in February 1890 to acquire E. N. Birkett. 135 tied houses. Brewing ceased in 1970, but the company continued with its pub estate, which was supplied by Whitbread. Demolished in 1986.

CHAPTER 6
Body and Soul

Forgive me for branching off our chronological tale of brewing in Britain, but I think it is worth spending a few minutes expanding on a legacy of ale that you might not have thought about. Ale, and beer, have saved millions of lives over the centuries. This is a claim I cannot easily substantiate, although, let me tell you a story that provides a good foundation to this claim. In 1850, Queen Victoria had a physician called Dr John Snow. At the time many parts of the British Isles, and London in particular, were being repeatedly ravaged by outbreaks of cholera. The authorities knew about the disease but most learned scientists of the time were firmly of the view that it was spread by miasma or bad air. Dr Snow, on the other hand, was not convinced. He spent many months studying the death rates and locations. Inspirationally he began to log these in what has now become standard practice, creating a map. Within the area of his study was Broad Street (now Broadwick Street) in the West End. In marking each death from cholera on a street plan he was able to see the concentrations of the deaths – and more revealing, the areas that had few or even none! Investigating these lead him to identify that the closer one came to the Broad Street pump, the communal water source for that street and its residents, the higher the death rate. So in a brilliant step he asked the local councillors to remove the pump handle and the outbreaks began to subside. However, this did not explain two areas where so few deaths occurred. Investigation revealed that one of them was simply that the families took their water from an alternative source, explaining that they did not like the taste of the Broad Street pump water. The second, and apologies for taking so long to get to the point, was around Mr Huggins' brewery. Snow interviewed the owner and Mr Huggins simply pointed out that why would his workers drink water when he supplied, free of charge, large quantities of free beer? Why indeed!

The healing and preventative properties of beer stimulated some hospitals to start their own breweries. In 1753 a Doctor Dobb was prescribing a quart of ale mixed with henbane, hemlock and other drugs before an operation. It ensured that the patient did not move during the operation. It is said his success rate for amputations was significantly better than most other doctors of the time. The Radcliff Infirmary in Oxford was first opened in 1770 and had a brewhouse behind the main building. The hospital porter would normally be responsible for brewing and the output would satisfy the needs of both patients and staff. In 1782 a Mr Hallam of the General Hospital in Nottingham was instructed to set up a brewery to serve the needs of the hospital. He bought all his equipment from the Feathers Inn just down the road. Once the brewhouse had been established, the doctors prescribed two and a half pints a day for both staff and patients. By 1819 this had fallen to one and a half for male patients and one for females.

As the nineteenth century wore on, it became clear that alcohol introduced as many evils as it cured and the practise started to fade away. However, there were still remnants

of the claims even as late as the 1960s when the Lion Brewery, Blackburn, advertised an oatmeal stout which was a 'splendid pick-me-up'. Mackeson and Sir Bernard Miles were plugging away with the statement, 'It looks good, it tastes good and by golly it does you good.' Meanwhile, Guinness left us in no doubt that 'Guinness is good for you'.

My outrageous claim that ale and beer have saved millions of lives is far more supportable when you look at the new industrial cities. London is a fine example as by the 1600s the Thames and all its tributaries were nothing more than open sewers taking the wastes of a city away on each tide. Hardly the stuff to cleanse the body. So ale and beer, using water drawn from wells and then boiled, was a sensible alternative.

While on this tangent to our story, it is worth mentioning that one of the biggest problems facing the sponsors and crews of ocean-going vessels until recent times was scurvy. It is clear from today's advanced medical knowledge that it all boiled down to the lack of vitamin C. In earlier days it was a curse. Many solutions were proposed and trialed, many failed.

One beer-based solution was tested during Captain Cook's second voyage in 1772. This proved successful and continued until 1798. Experimental brewing using hopped malt extract was regularly carried out on ships of the Royal Navy in an all-out effort to discover a beer concentrate that could be used at sea. Rations on board a Royal Navy ship consisted of ship's biscuits, salt beef and pork, and a gallon of beer a day. As longer voyages became more prevalent it was quickly noticed that scurvy presented no problem so long as the beer held out.

The Admiralty followed eminent doctors' recommendations and started to install 'floating breweries'. Cook's surgeon, however, a young man named Perry, wrote after the voyage 'that the Malt is the best medicine I know, the inspissated Orange & Lemon juices not even excepted.' The main problem was that the men who declared the experiment a success had never tasted the mix. Although it did the job of warding off the scurvy, it did nothing to excite the taste buds of the crew. They refused to touch the foul-tasting drink and brewing at sea ended in failure. This was to have a far-reaching effect on naval life. As a result, the navy may never have formed its traditional link with rum and, more interesting, the Americans might be calling us 'malties' rather than 'limeys'.

While we are all at sea, let me tell you the story of another naval experiment with beer. In 1944 the Board of the Admiralty decided that in order to ensure an adequate supply of beer to our troops fighting in the Far East, it would be practical to install floating breweries at Pacific harbours. The plan called for 'amenity ships' which had, as well as a brewery, a cinema, theatre, dance hall, barbers, shops, bars and tailors facilities fitted. Only one ship actually completed its refit – T.S.M.V. *Menestheus*. As with Cook's experiment, the brewing was done using malt extract and hop concentrate, the yeast being sent in from the University of British Columbia's Faculty of Agriculture (having been originally supplied by the Guinness Brewery, Park Royal, London). Despite missing out on active service, the *Menestheus* did a great deal of good for the troops in Hong Kong. At one point consumption reached a staggering 400 gallons per day.

CHAPTER 7
Beer and Technology

The big brewers of Britain were always seeking ways of increasing their efficiency at a time when their product was in huge demand. Their drive for increased profits and reduction in costs led them to explore some of the technical developments that were powering the Industrial Revolution. In the 1780s Whitbreads were in need of increased power to drive the brewing process. They realised very early on that moving huge amounts of raw materials around their Chiswell Street Brewery would take more than men and horses to achieve. They employed the famous firm of Boulton & Watt to install a stationary steam engine. The Whitbread engine was installed in 1785 and was supervised by John Rennie, who also built London, Southwark and Waterloo Bridges. Around the same time John Smeaton designed the vast cisterns that populated the basement of Chiswell Street. He also designed the Eddystone Lighthouse. This proved highly successful, if not a little bit expensive. The steam engine allowed them to get the malt and hops to the right place as well as pump the beer in its various stages around the site. So proud were they of this marvel of the age that in 1787 they invited King George III and Queen Charlotte to view the machine – an early example of the power of celebrity. In fact, that very same steam engine can be seen today in two places. The Museum of Power in Sydney, Australia, houses the machine itself in full working order; if you don't want to travel quite that far, just grab a £50 note. The steam engine behind James Watt is the very one the king and queen saw.

Interestingly, the original definition of the term beloved of petrol heads, horse power, assumes the work of an engine can be measured by comparing it to a horse. Not any old nag but a brewery horse, implying they were not only hard working but also worked hard. In 1784, the leading steam engineers Boulton & Watt were commissioned to install an engine in the go-ahead firm of Messrs Barclay, Perkins at the Anchor Brewery in Southwark. William Murdoch, who supervised the installation, needed to measure the power of the engine. He came up with a calculation based on the only thing that he had at the time that could power a machine – the horse. He observed that an average brewers' dray could move 22,000 pounds over 1 foot in 1 minute. Allowing for a margin of error, he set his measurement at 33,000 feet pounds per minute, thus creating the horse power unit of measurement, which has been used ever since.

As is typical of technology, there were always going to be spin-offs. For example, as the need for more power increased, the more the engine manufacturers pushed the pressures within their boilers. At Reid's Griffin Brewery in Holborn, London, in 1800 the chief engineer, Arthur Woolf, had become somewhat of a leading expert in high-pressure steam. So much was his opinion valued that he was often called upon to consult and advise others who were experimenting with this potentially dangerous source of energy. One person he guided was Richard Trevithick, currently attributed with the invention of the steam engine

on wheels. Maybe not exactly the father of the railways but certainly a pioneer of high powered steam and the builder of several self-powered vehicles. Trevithick would often attend Reid's brewery in order to try out one piece of machinery using the steam engines on site.

When the newly popularised railways became the solution to every manufacturers' transport restrictions, they jumped on the bandwagon – or more correctly, the beer wagon. Soon huge amounts of beer were being hauled around the country behind the iron horse. Eventually, most of the major brewers not only had fleets of wagons and tankers decorated in their corporate colours, but also sidings of differing sizes branching off the local main lines. For example, Benskins of Watford had sidings that ran directly off the mainline. Mitchell & Butlers ran sidings which branched off the Birmingham to Wolverhampton main line. William McEwans of Edinburgh had six private sidings off the main Glasgow to Edinburgh line. Peter Walkers of Warrington had connected up his brewery by as early as 1831 (they even owned a local pub called the Three Pigeons Inn, which also served as a booking office and waiting room).

An interesting decision that would face any board of brewery directors planning a rail network would be gauge. Guinness in Dublin, for example, went for a narrow gauge, while almost all the British brewers stuck with the emerging national standard, except one. Way over in Oakhill, Somerset, the local brewer and maltster decide to commission their internal network on a 2-foot 6-inch gauge. Of course this required movement of stock onto standard-gauge wagons when the smaller trains drew up at the mainline rail head. Picturesque, I'll grant you, but economically viable, I'm not so sure.

In 1936, when Guinness decided that the British trade was sufficient that it warranted its own more local brewery, they commissioned Park Royal in West London. Integral to its design was an internal rail network. They already knew that this was an efficient way to get the product out to the customer as they had been running their own at the St James' Gate Brewery in Dublin since 1874. Admittedly, the Dublin internal network was narrow gauge (1-foot 10-inches) and the Park Royal network was standard gauge. A lesson learned perhaps? Engineering difficulties were always going to happen when established brewery sites looked to the more recent rail network for assistance. In Romford, the handy newly constructed line to East Anglia passed very close to the Ind Coope brewery – horizontally close that is, as vertically the two were a long way apart resulting in the use of a wagon hoist. Eventually the hoist was retired in favour of a gentle slope! They learned a lesson from this and when they established their Burton Brewery in 1858 they made sure the land was adjacent to, in all senses, the Midland Railway main line.

It was in Burton that beer and railways joined in chaotic harmony. At its height, the town was a maze of over 40 miles of interconnecting sidings, level crossings and road junctions. All the major companies had sizable internal railways with level crossings on all the town's major roads, all of course manually operated. It also required smaller and more manoeuvrable locomotives, resulting in unusual and distinctive designs. Of course Bass, as Burton's main brewer, had a sizeable chunk of the railway tracks within the town, of the 40 miles or so Bass controlled 26 of them.

When the drive to create continental-style lager beer was underway in the late nineteenth century, Wrexham in North Wales was chosen by a group of Bavarians to try and develop a trade in the beer style. They installed a large set of sidings close to the brewery as their objective had always been to get their beer nationwide to maximise sales.

It would be wrong of me to mention the use of the railways by the brewers without tipping my hat to one of the cathedrals of beer, a veritable temple of the industrial revolution that exists solely because of beer. Of course the attractions of the biggest market for beer in Britain, London, was a far too tempting target for the ambitious Burton Brewers. They felt that having been isolated for many years by distance this was their time to move in and clean up. They knew their pale ales could make inroads into the monopolistic porter. They were also up to speed on the technologies. So, by putting pressure on the London Midland Railway they began to develop a rail link, late in the day admittedly. In 1866 work began at St Pancras for the new London Terminus for the Midland Railway. Because of the nature of the ground in the area, the rails ended some 20 feet above the Pentonville Road. Early plans showed a station with a double- or triple-span roof with all the spoil from the building work being used to fill in the void between ground level and platform level. The general manager of the Midland at the time, James Allport, realised that this space was far too valuable to waste and ordered a redesign to turn the area into storage and cellarage. The consulting engineer, William Barlow, was well aware that the main use for this cellarage area would be the storage of barrels of Burton Beer. He decided very early on in the design work to discard the standard imperial measurements of feet and inches and instead use the standard beer barrel as his unit of measurement. This revolutionary concept allowed the height and width of the cellars and their supporting pillars and beams to offer the maximum storage space to the brewers of Burton. This measurement still exists today in the beautifully restored St Pancras International. The Eurostar and domestic trains all arrive and depart for platforms still at that original height level, while the Undercroft houses the usual array of retail outlets with the original supporting pillars still intact. If you do visit, pay homage to Sir John Betjeman, without his lobbying this fascinating piece of brewery history would have been lost. The cellars were fitted with a vast array of interconnecting rails to allow the maximum versatility in the movement of barrels. There were points, turntables, capstans and rope pulleys, even a hydraulic lift. The movement of trucks and locomotives was controlled by its own signal box.

It was not just in transport that the brewers began to seek technology's help. Until the start of the nineteenth century little was understood about the science behind the brewing process. The mash was created with water and hops were added, all that was easy to fathom out by the brewers of the time. Then the yeast was introduced and something magical happened. The sugars turned to alcohol and the beer gained a flavour all of its own. In early times the yeast was not always introduced by the brewer. While the Sumarians decided it was worthy of a deity, the Victorians knew there was something else afoot, but they didn't know what!

Then along came Louis Pasteur, waving his microscope. He had already spent a great deal of his life investigating the properties of yeast. In 1854 he was appointed Professor

of Chemistry and Dean of the Faculte des Sciences in Lille. The following year he began to take a special interest in alcoholic fermentation. In 1863, after publishing many scientific papers establishing the basic concepts of fermentation, he turned his attentions to diseases of wine. During his investigations he discovered that each infection had its own cause and its own special organisms. To stop this he devised the technique now known as pasteurisation.

In 1871 the French were subjected to a crushing defeat at the hands of the Prussian army. Pasteur, a deeply patriotic man, vowed to do something to regain just a small piece of national pride. He decided to make French beer better and more reliable than German beer. By applying sound scientific principals involving cleanliness and sterility, he designed a method that drastically improved the quality of the beer, thus removing many of the diseases that consistently attacked the batches of beer. His success was on a small scale and he wanted to see if he could apply his techniques to a large operation. As the use of a large German brewery was out of the question, he crossed the channel and made an appointment to visit Whitbread's Chiswell Street Brewery in September 1871.

Using his trusty microscope, very rare in the breweries of the time, he was able to immediately show the surprised brewery managers that the current batch of porter was well on the way to being spoiled. With a Gallic shrug he proclaimed 'This beer leaves a lot to be desired', but in French. The yeast had become contaminated. While he was there he went on to condemn their pale ale as well. The managers reacted immediately and sent for a new batch. Pasteur left the brewers to act on the hygiene processes he had given them. They did, their first act was to purchase a microscope for the laboratory. The beer scientist had been born and the brewers never looked back, in fact they started looking down!

Continental Lager – A New Threat to Brewers

Lager is a German word meaning 'store' but the only difference between beer and lager is the yeast that is used. Bavarian brewers noticed that their local wild yeasts produced a pale beer which was bottom fermenting (beer yeast ferments at the top). A Bavarian monk is said to have smuggled a sample of this yeast from Munich to Pilsen in 1842 where it was used to brew the first style of beer for which Pilsen subsequently became famous. In 1845 the Danish brewer J. C. Jacobsen, who was visiting the Spaten Brewery in Munich, was given some of this yeast to take back to Copenhagen. This he used to produce beer at his brewery, later becoming the famous Carlsberg Brewery. Inevitably, the news of this 'new' beer style was communicated back to the brewers of Britain. Of course the brewers here disregarded this as just a passing fancy. As it turned out it was not passing at all but soon became firmly entrenched in European breweries. Inevitably, and somewhat reluctantly, the brewers of Britain began to experiment with this new-fangled beer style during the late 1800s.

The *Bradford Daily Telegraph* reported on Friday 2 October 1868 that,

> The brewers have now another rival in the field. There can be little doubt but that the introduction of light claret and other cheap wines into this country must have diminished the sale of beer amongst the middle classes to some degree, but during the last hot weather the sale of Vienna beer was attempted on a small scale in the City, and it was found to take so with all classes that there are now five establishments where this beverage may be procured in London.

So by the 1870s lager had become available within the British Isles. However, the British drinker did not take to it immediately. Because of its bottom fermentation and the need for strict low temperature control, it gave the brewers of the day a whole new set of challenges. As refrigeration was very much in its infancy, and the perceived market for continental beer was very small, the British brewers were reluctant to switch. However, they soon started to sit up and take notice as more and more imports flooded into the country.

The claim to be the earliest brewer of lager in the United Kingdom is a hotly disputed title. William Younger of Edinburgh made a trial brew in 1879 using that bottom fermenting yeast which had been imported from the Carlsberg brewery in Copenhagen. The Glasgow Wellpark Brewery of Robert Tennent began an experiment to brew lager in 1885. The findings were of sufficient success to begin the construction of a purpose-built lager brewhouse by L. A. Reidinger of Augsberg in 1889. This was complete two years later; the buildings were finally demolished in the 1960s.

The Wrexham Lager brewery was constructed by a group of German merchants in 1882. It was based on a brewery at Pilsen and took seven years to complete. The main instigator

of this enterprise was Robert Ferdinand Graesser, a German migrant worker. Despite bringing in a brewer from Pilsen, his enthusiasm for this type of beer was not shared by the drinkers of Britain. The venture ran into financial trouble and was declared bankrupt in 1900. The company was not without its success, when in 1898 a bottle of Wrexham Lager was found at Khartoum when the town was relieved by Lord Kitchener's army.

Samuel Allsopp began lager brewing at Burton upon Trent in 1899 but this was brought to a dramatic close when the brewery burnt down in 1910. Some plant was saved from the flames and re-erected in Alloa, Scotland, and brewing restarted.

The *Brewers' Journal* of 15 November 1923 reported that the eminent medical journal, *The Lancet*, had analysed two samples of Barclay, Perkins & Co.'s lager beer. Their findings were that,

> Both these beers, which are stronger than the continental lagers, were brilliant, in excellent condition, and contained no sediment. They possess the true lager characteristics, are most palatable and refreshing beverages, and have evidently been brewed with the greatest care and skill. Messrs Barclay are to be congratulated on their enterprise in placing a true 'lager' on the market, the more so as such beers are held in great esteem by beer drinkers with a 'refined' palate who can appreciate a sound and wholesome beverage brewed by a method hitherto but little exploited in this country. Medical men have every confidence in recommending these beers as they are fully fermented and matured.

In 1900 lager was being brewed in small quantities in over a hundred breweries up and down the country. Some brewers even dedicated themselves to the product. There was the mouth-watering Tottenham Lager Beer and Ice Factory Ltd, of course the soon-to-be non-politically correct Anglo-Bavarian brewery in Shepton Mallet and the very politically correct British Lager Brewery Co. in Liverpool. Not surprisingly, the two world wars helped quash the product.

If there was a turning point in the popularity of lager beer it came in the 1950s in the ambitious plans of Candian E. P. Taylor. One could describe Taylor as a brewery magnate, but not in the same way the existing UK 'beerage' was. Between 1934 and 1954 Taylor had built up his own company, Canadian Breweries, through a series of rapid mergers to the point where it supplied over half the total output of beer in the provinces of Quebec and Ontario.

Taylor saw that in exchange for introducing British-style beer into Canada, he could expand sales of his Carling lager brand into the UK and onward into Europe. In 1953 he began discussions with the Hope & Anchor Brewery of Sheffield. The deal was just what the board of the Hope & Anchor were looking for, a way to sell their Jubilee Stout in Canada, so they met with Taylor's company. He demanded a reciprocal deal, which was that each should brew the other's product, to which they agreed, and thus were in the position of obtaining excellent help in brewing lager. However, Taylor's ambitious plans could not be achieved with the tied estate that the Hope & Anchor had, which was far too small.

Taylor took some time to appreciate the UK tied house system. He soon understood what was necessary to be done, to persuade small brewery companies, as a deliberate policy, to sell out and come in with his British company. This was not only a progressive idea for the 1950s, it was also that the brewing industry was a closed, inward-looking cartel, which only ever spoke to its own. In Taylor's view, the industry was ripe for rationalisation.

Most of the small brewery companies were only too pleased to negotiate with him, as he offered to take their run-down breweries, with their infected brewhouses and tumbledown pubs, from them for lovely money, leave them as directors, and with the impression everything would go on as before. Of course it did not, as his experts moved in and began closing up and consolidating brewing.

From 1953 Carling was brewed and bottled by the Hope & Anchor Breweries Ltd. By 1958, the Hope & Anchor's limitations became apparent, primarily only 150 tied houses. Taylor had bought the shareholding in Hope & Anchor to use it as a stepping stone to create a national brewing group in the UK. He persuaded many breweries to join the group.

So in 1959 Taylor created Northern Breweries by merging the Hope & Anchor Brewery, Hammonds United Breweries and John Jeffrey & Co. of Edinburgh. Hope & Anchor themselves had not been idle in the brewery/tied house acquisition game. They had already gotten their hands on R. F. Case & Co., John Aitchison & Co., Bentley & Shaw Welcome Brewery Co. and G. S. Heath Westoe Breweries.

Northern Breweries then took over a further sixteen breweries in the next two years. Becoming United Breweries in 1962 with 2,000 outlets. Then United Breweries in 1962/3 merged with the London brewer Charrington. They in turn merged with Bass to create a giant UK and overseas trading conglomerate. Thus, by 1970 Taylor's empire in the UK covered 9,736 licensed premises and 2,640 off-licences. There was also a large but undisclosed club and private trade.

The impact of this 'smash and grab' approach to expansion was not fully appreciated until the 1970s.

The Fall and Rise of British Brewing

From 1760 onward, the centuries-old resolve to keep beer pure began to give way under the pressure for better return on investment. More and more publicans began to chance their luck and added a little something to make the ale and beer last longer. By 1790 the adulteration of ale and beer had reached epidemic proportions. The main adulterant at that time was 'Cocculus Indicus', or Indian Berry, a highly poisonous berry of the deadly nightshade family. The threat to sales from the increase in gin drinking gave the publicans little option but to try and make a barrel last longer. The temptation to get just one more day out of their purchase by artificial means was just too great.

For hundreds of years the adulteration of beer and ale was strictly prohibited by law. So serious was the nature of this crime in the eyes of the population that the punishments were extreme. Even as far back as the Domesday Book of 1086 there are mentions of bad brewing of ale, with the punishment of a 4 shilling fine or that other favourite chastisement of the age, the ducking stool.

Later, towards the end of the nineteenth century, one of the constant bugbears suffered by the brewers was the extensive counterfeiting that was rife. Guinness is a prime example. Having taken their marketing and distribution model in a different direction to most of the other brewers, it supplied bulk stout to smaller bottling and distribution companies. It did not take long for the more unscrupulous firms and individuals to start to put inferior products in the bottles while claiming them to be the original items. Guinness labels declared the stout to be from Dublin, but the contents were often from nowhere near. The government of the time decided that one way to tackle this was by creating the Trade Mark Act. The story goes, without any supporting evidence, that Bass so wanted to be Trade Mark No. 1 that they sent a worker to sit outside the patent office the night before the legislation came into effect. Whether this was true is debatable and awaits some supporting evidence, but they certainly did get the No. 1 Trade Mark, registering the still familiar Red Triangle in 1876. While they were at it, they collared Trade Mark Nos 2 and 3.

Clearly additional capital was always needed. For modernisation, for acquisitions, for upkeep of an increasing tied house estate. However, unless the family were wealthy to begin with, where does one get it? Long before the advent of crowdfunding and venture capitalists, Guinness had one answer. In 1886 they decided to float themselves on the Stock Exchange. The subsequent floatation raised £6 million and as a result was substantially oversubscribed. The money raised was spent on increasing the export capability of the brewery, a capability that was already sending the 'black stuff' to all corners of the world. Then, as it is now, Guinness was one of the most widely recognised brands, and coupled with it was the inbuilt 'Irishness'. Drinkers across the globe knew Guinness and they also knew where it came from. The share issue was watched closely by other brewers. The

success soon fueled a wave of floatation within the rest of the brewing sector. Some of the brewers sought to merge with other brewers prior to going to the market for a floatation, seeing their increased size, and therefore share value, as a positive thing for potential investors. The value of the companies floated reflected the assets of the companies involved, substantial estates of property and the easy recognition of their names and products by the share-buying public.

As both brewer and publican were under mounting pressure to increase profits and decrease costs, pasteurised beer seemed to be the magic bullet. This idea was not new. In 1936 at a small club called the East Sheen Tennis Club, an experiment that was to revolutionise and at the same time vilify big brewers was conducted. Their problem, which they shared with their beer supplier, Watneys, was that they sold most of their beer at the weekend. Thus, they wasted a lot of beer as it went out of condition over the inactive weekday period. This got Watney thinking and so they tried a new idea they had been toying with – pasteurized beer, an idea they had been working on to help with the long journeys to British troops abroad. Applying it to more local markets had not been tried. Although not the first to try this approach to beer, Bass had done similar experiments in the nineteenh century, this attempt proved to be very successful. The marketers at Watney's also developed a name for the East Sheen Tennis Club's new product – Watney's Red Barrel. The rest as they say is history, but history that didn't really get going for another twenty years!

Oddly, having proved the viability of the product at East Sheen, it was not Watneys that capitalised on it. During the Second World War Simonds of Reading, in an experimental plant at the Tamar Brewery, attempted to make the keg idea more commercial but could not stabilise the beer. The brewery engineers continued to work on the idea, until eventually in 1953 the first commercial sales were made by the Flower's Luton Brewery, soon to become part of the Whitbread Empire. You may well remember some of the other national brands that soon emerged, Whitbread Trophy, Ind Coope Long Life and their equally famous Double Diamond, and, of course Watney's Red Barrel. The beer was sterile with all secondary fermentation stopped and ready for almost immediate consumption. When combined with carbon dioxide pressure to aid the movement from the pub cellar to the bar, resulting in a carbonation, a fizzy bland drink was the result. It was this national, fizzy drink that stimulated perhaps the world's greatest consumer revolt. Rather than the 'Red Revolution' that was the dream and strapline of the Watney's marketing team, it created the awareness that there was now something being lost from the bars of the nation.

Commonly called keg as no one single brewery could register the name, the process stopped all secondary fermentation and removed the need for skill in the pub cellar. In 1960 a mere 1 per cent of all beer sold was attributed to keg. This rose steadily to over 40 per cent in 1976. Over this period the brewers took the opportunity to reduce the strength of the keg beers. Watney's Special was measured at 1043 OG in 1960, 1037.9 in 1971 and 1036 OG by 1972. This gave the local drinks less choice as local brewers' houses became regional brewers' houses. It also brought the newly created large regionals into the sights of brewers with national aspirations.

Into this vast wilderness of nationwide keg stepped CAMRA. They knew beer shouldn't taste like this or look like that. Combined with the smaller regional brewers who were keeping up the age-old traditions of beer production, they began to re-educate our palates and stimulate demand for the 'natural' beers of Britain. The term 'real ale' was coined, implying that the Red Barrels of this world were not 'real'.

From the depths of the keg desert that was quickly confronting the British drinker arose a new band of brewing entrepreneurs – the micros. What almost started as a rebellion to the national availability of the big brewers' brands, microbreweries are now successful by creating tempting and unusual brews, retailing to a small number of pubs and outlets. In the most part they were successful and just a little bit fashionable.

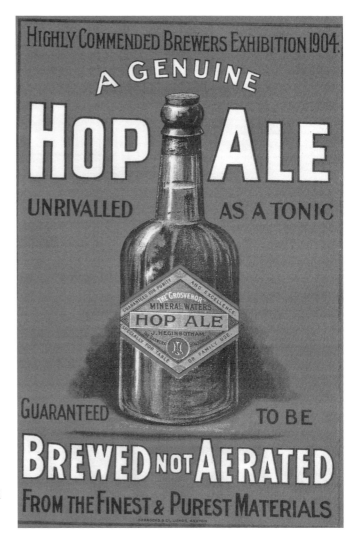

John Heginbotham Ltd, Borough Brewery, Borough Street, Stalybridge. Registered in April 1908. Voluntary liquidation on 23 November 1914 and acquired by Frederic Robinson Ltd in 1915.

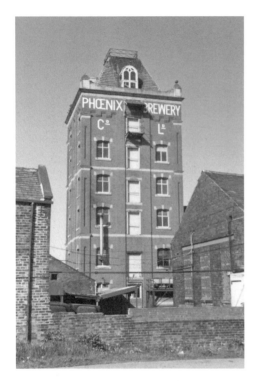

Phoenix Brewery Co. Ltd, Green Lane,
Heywood, Manchester. Registered in 1874.
Acquired by the Cornbrook Brewery Co. Ltd
in 1937 with 127 houses. Cornbrook then
registered a new company of the same name
in 1939 as a subsidiary.

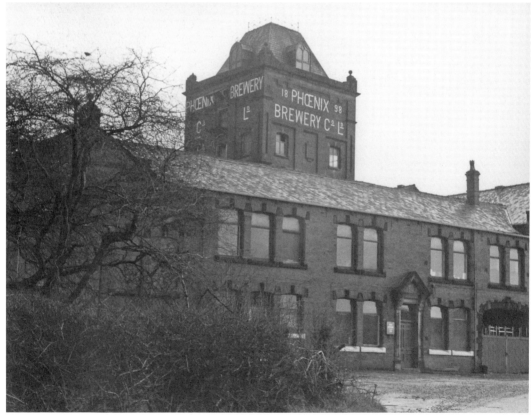

Courage & Co. Ltd, Anchor Brewery, Horselydown, Bermondsey SE1. Acquired by John Courage in 1787. Registered in April 1888. Merged with Barclay, Perkins & Co. Ltd in 1955 with approximately 1,250 houses to form Courage & Barclay Ltd. Merged with H. & G. Simonds in 1960 to form Courage, Barclay & Simonds Ltd. Name changed to Courage (Eastern) Ltd in October 1970. Acquired by the Imperial Tobacco Group Ltd in August 1972. Anchor Brewery closed in 1981 and brewing was transferred to Worton Grange, Reading. The Imperial Group was acquired by the Hanson Trust in 1986, who sold Courage as a separate concern to Elders IXL. Courage took over all of the Grand Metropolitan breweries in exchange for the Courage public houses, which were run by a jointly owned company, Inntrepreneur Estates. Courage were sold to Scottish & Newcastle to become Scottish Courage. Brewhouse now riverside residential apartments.

North Country Breweries Ltd, Anchor Brewery, Silvester Street, Hull. Founded in 1765 as John Ward's Brewery, Dagger Lane. Moved to Anchor Brewery in 1868. Registered in January 1888 as the Hull Brewery Co. Ltd to acquire Gleadow, Dibb & Co. Acquired by Northern Dairies Ltd in 1971 with 212 tied houses and name changed in 1974. Bought by the Mansfield Brewery Co. Ltd in May 1985 and brewing ceased.

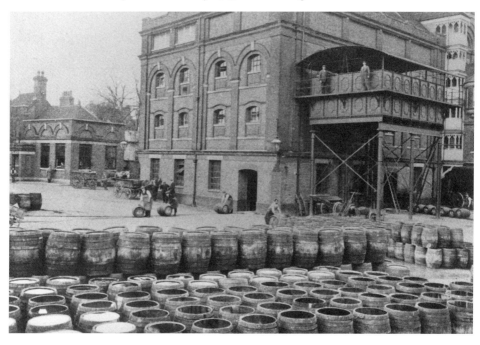

Isherwood, Foster & Stacey Ltd, Lower Brewery, Lower Stone Street, Maidstone. Possibly founded before 1650. Registered in August 1891. Acquired by Fremlins Ltd in 1929 with 151 public houses and was closed. Brewery demolished.

Workington Brewery Co. Ltd, High Brewery, Bridge Street, Workington. Founded by John Christian Curwen (Lord of the Manor) in 1792 on leased land. Commenced trading in 1795. By 1839 it was in the ownership of John Iredale, previously of Keswick. Registered in May 1891 to acquire the business of P. & T. Iredale. Acquired by Mount Charlotte Investments Ltd in 1973 with 110 public houses and sold to Matthew Brown & Co. Ltd in June 1975. Renamed the Lakeland Lager Brewery and ceased brewing in 1988. Some buildings remain.

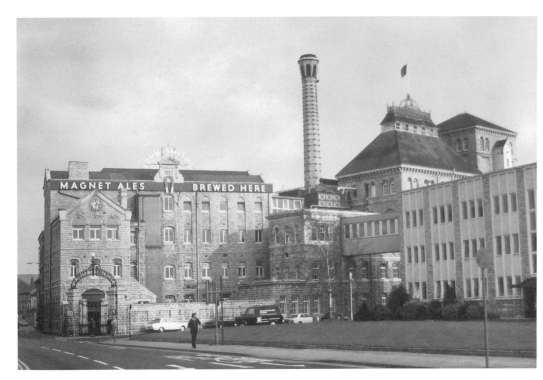

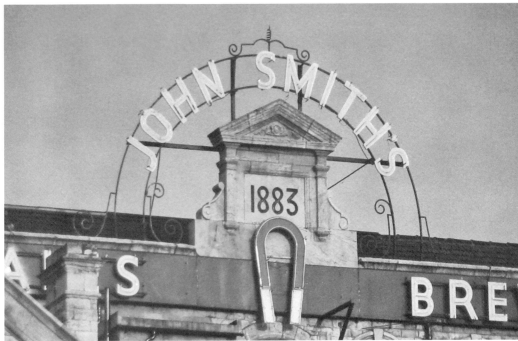

John Smith's Tadcaster Brewery Co. Ltd, High Street, Tadcaster. Acquired by John Smith in 1847. Present brewery built in 1884. Registered in August 1892. Acquired by Courage, Barclay & Simonds Ltd in 1970 with approximately 1,800 houses. Brewery still in operation as part of Heineken UK.

Kemp Town Brewery (Brighton) Ltd, Bristol Brewery, 6 Seymour Street. Founded before 1833. Registered in March 1933 to acquire Abbey's Kemp Town Brewery. Acquired by Charrington & Co. Ltd with 236 houses in 1954 and brewery vacated in 1964/65.

Jonas Alexander & Sons Ltd, Beezon Lane Brewery, Sandes Avenue, Kendal. Founded in 1822 as E. Hayton & Co. Registered in December 1927. Acquired by Dutton's Blackburn Brewery Ltd in 1947 with thirty-one tied houses. Brewery closed in 1951 due to rising costs. Premises now an insurance office.

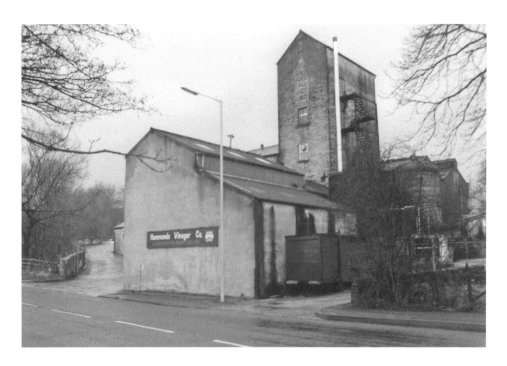

John Kenyon Ltd, Rossendale Brewery, Bacup Road, Barrowford. John and William Kenyon built the Rossendale Brewery in Bacup Road, Clough Fold, in 1867. John Kenyon acquired Hartley and Bell's Clough Springs Brewery in Wheatley Lane Road, Barrowford, with six houses in 1888. Registered in 1897 to acquire both breweries. Acquired by Massey's Burnley Brewery Ltd in December 1928 with seventy-eight houses.

E. Smithwick & Sons Ltd, St Francis Abbey Brewery. Founded in 1710. Registered in 1899. A Guinness subsidiary through Irish Ale Brewers since 1965. Now Diageo. Closed in 2008.

Wrexham Lager Beer Co. Ltd, Central Road. Founded by Ivan Levenstein in 1878 as the Wrexham Brewery Co. and Robert Graesser soon acquired the majority shareholding. Registered as the Wrexham Lager Beer Co. in 1881, and became a limited company in 1900. Acquired by Ind Coope Ltd in 1949. Closed in 2000 and demolished.

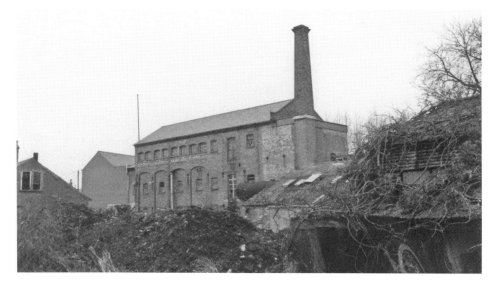

J. & C. T. Lindsell & Son, High Street, Chatteris. Founded before 1839 and acquired by Thomas Lindsell by 1851. Brewing ceased in 1927 and their beers were produced by Marshall Brothers (Huntingdon) Ltd. In 1932, they merged with them to form part of Huntingdon Breweries Ltd. Used in the late 1980s as an insulation factory and the building is now flats.

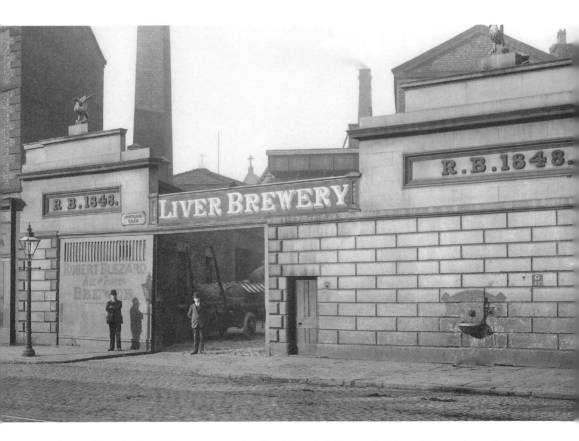

Robert Blezard, Liver Brewery, 419 Scotland Road, Liverpool. Blezard moved to the Liver Brewery from the Bootle Brewery in 1848. Acquired by Walker Cain in 1921 with forty-eight public houses.

Opposite above: Charles Richard Luce, Mill & Abbey Breweries Malmesbury. Acquired by the Stroud Brewery Co. Ltd in 1912 with forty-five tied houses and was then closed. The Abbey Brewery is still standing, having being converted into offices in 1989/90.

Opposite below: Henry Luker & Co. Ltd, Middleton Brewery, 123 High Street, Southend. Founded *c.* 1865. Registered in July 1895. Acquired by Mann, Crossman & Paulin Ltd in 1929 with forty-three public houses for £285,000.

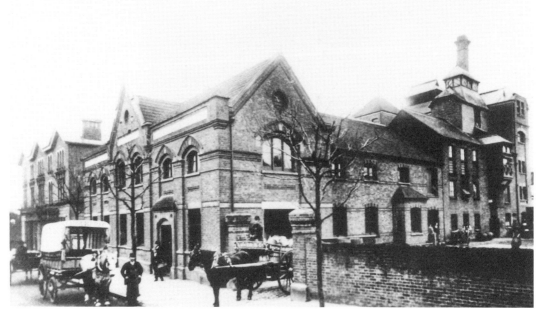

This and next three pages: Henry Mitchell & Co. Ltd, Cape Hill Brewery, 71/72 New Street, Cape Hill, Birmingham. Henry Mitchell Jr built the Cape Hill Brewery in 1878 to replace the Crown Brewery, Smethwick. Registered as above in 1888. Merged with Butler's Crown Brewery Ltd in 1898 to form Mitchells & Butlers Ltd. Merged with Bass, Ratcliff & Gretton Ltd in 1961 to form Bass, Mitchells & Butlers Ltd. Closed in 2002 after the acquisition of Bass by Molson-Coors.

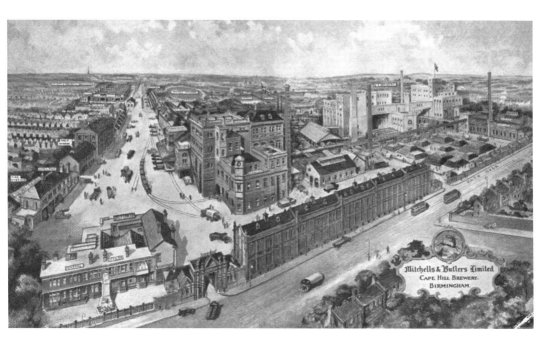

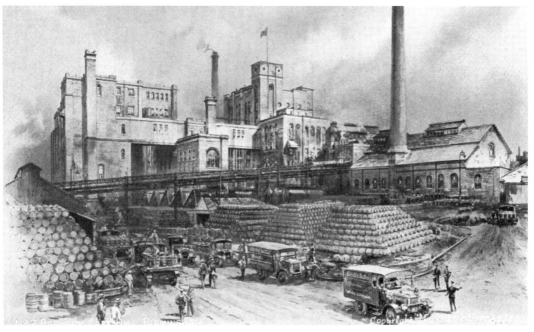

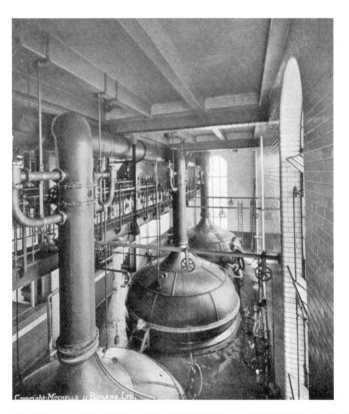

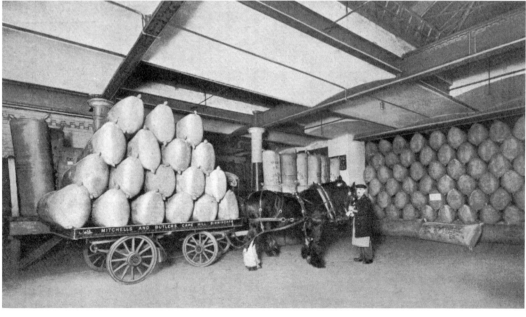

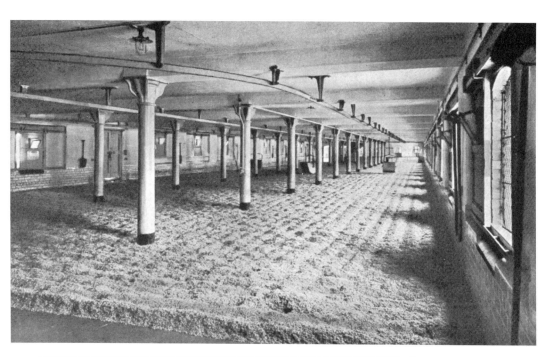

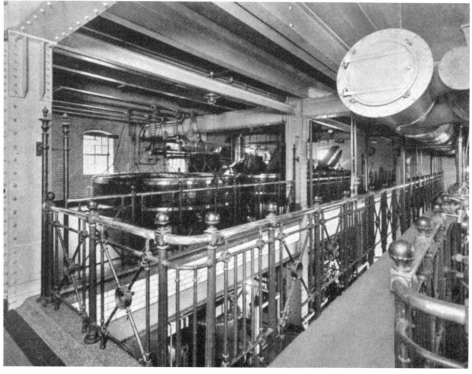

Kirkstall Brewery Co. Ltd, Kirkstall, Leeds. Operated by Thomas Walker from before 1834. Acquired by Benjamin Dawson *c.* 1845. Registered in June 1871 to acquire Benjamin Dawson & Co. Reconstructed company registered in January 1899. Acquired by Dutton's Blackburn Brewery Ltd in 1936 with eighty-three public houses. Brewery bought by Whitbread & Co. Ltd in 1953 and closed in January 1983. Now student accommodation.

Maclay & Co. Ltd, Thistle Brewery, 1 Junction Place, Alloa. Founded by 1830 when James Maclay leased the Mill Brewery. The Thistle Brewery was built in 1870 and the Mill Brewery was leased to Robert Henderson. Registered in 1897. Closed in 1999 in favour of pub management. All Maclay beer is now brewed by Belhaven and the Thistle brewery has since been demolished.

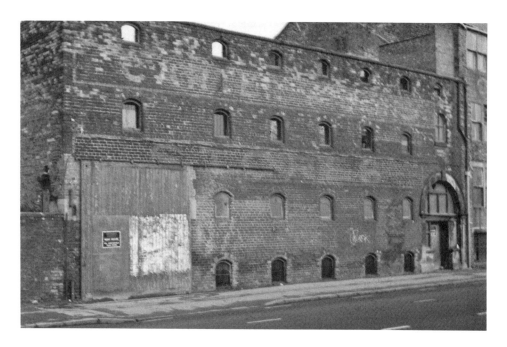

Thomas Marrian & Co. Ltd, Burton Weir Brewery, Royds Mill Street. Founded in *c.* 1830. Registered in March 1882. Acquired jointly by the brothers F. A. Kelley of Sheffield and James Kelley of Wath in 1903. The sixty-six houses were divided between Whitmarsh, Watson and Whitworth, Son & Nephew Ltd. and the brewery was closed.

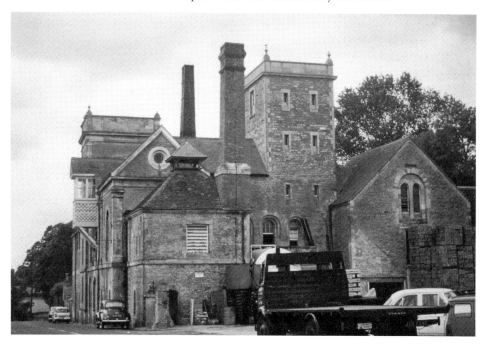

Matthews & Co., Wyke Brewery. Founded eighteenth century. Acquired by Hall & Woodhouse Ltd in 1963 with sixty-one tied houses and closed. Partly demolished in 1985, the remainder converted to multiple residential use in 1988, this part having been built *c.* 1860.

Minera Brewery, City Arms, Wem Road, Minera, Clwyd. A home-brewhouse founded in February 1984 by Lloyd & Trouncer (Allied Breweries) that ceased brewing in 1989.

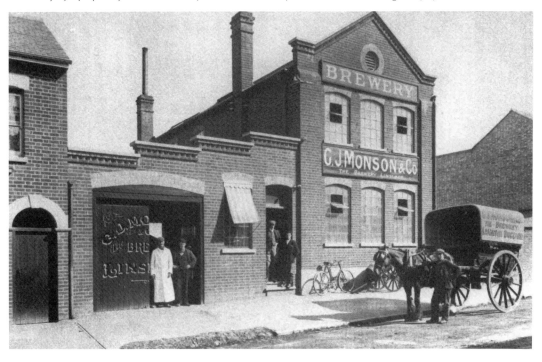

Linslade Brewery Co. Ltd. Registered in May 1904 to acquire G. J. Monson & Co. and the breweries at Wing Road, Linslade, and Leighton Buzzard. Dissolved on 20 November 1908.

This and next two pages: Morland & Co. Ltd, Eagle Brewery, Ock Street, Abingdon. Founded in 1711 as maltsters at West Ilsley by Benjamin Morland. Eagle Brewery acquired in 1861 and Abbey Brewery in 1866, both in Ock Street. Brewing was concentrated at the Eagle Brewery. Registered in October 1887. After the purchase of Ruddles in 1997, financial problems culminated in the purchase in 1999 by Greene King. The brewery was closed and converted into housing, the brands being transferred to Bury St Edmunds.

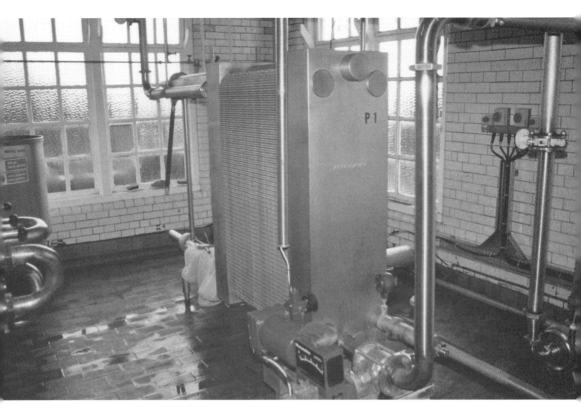

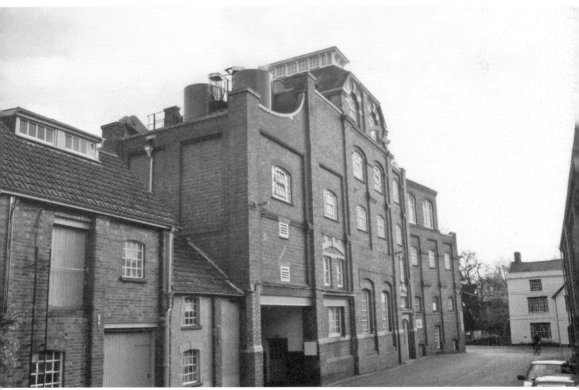

105

Ansells Brewery Ltd, Aston Brewery, Park Road, Aston Cross, Birmingham. Founded as maltings by Joseph Ansell in 1857. Sons William and Edward added the brewery in 1882. Registered in 1889 as Joseph Ansell & Sons Ltd, re-registered as above in June 1901. Had over 1,890 houses in 1973. Merged with Ind Coope and Tetley Walker to form Allied Breweries Ltd in 1961 with 2,400 houses. Aston Brewery closed in 1981.

Opposite above: Nicholson & Sons Ltd, High/Pineapple Brewery, 75 High Street, Maidenhead. Founded by Robert Nicholson in 1840 as the Pineapple Brewery. Registered as a limited company in 1903. Acquired by Courage, Barclay & Co. Ltd in 1958 and closed in 1961. Now the Nicholson Walk shopping complex. Stables remain.

Opposite below: J. Nimmo & Sons Ltd, Castle Eden Brewery, Castle Eden, County Durham. Founded by John Nimmo in 1826. Registered in December 1892. Public company formed in 1956. Acquired by Whitbread & Co. Ltd in October 1963 with 125 tied houses. Sold by them to a management buy-out. Some buildings remain.

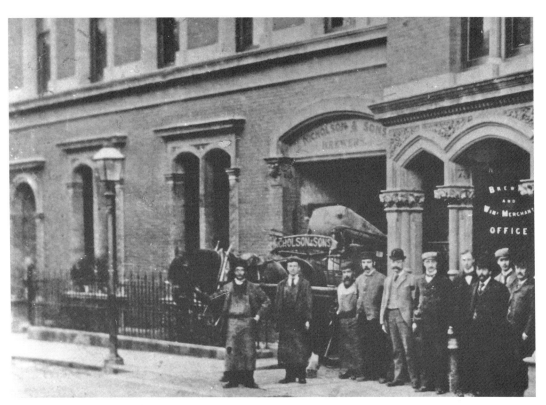

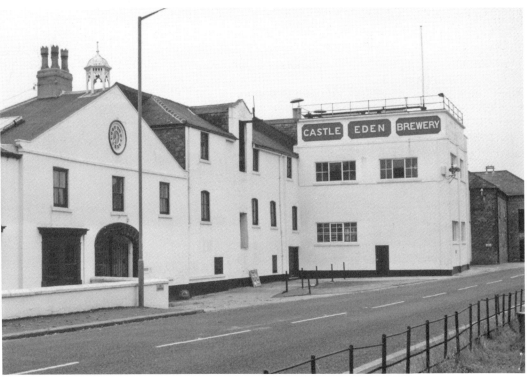

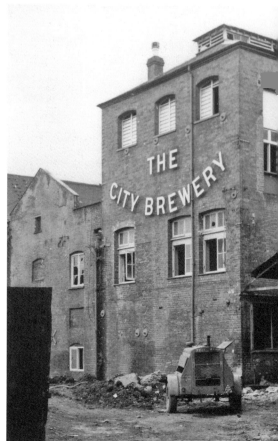

This and next page: Norman & Pring Ltd, City Brewery, 1 Commercial Road, Exeter. Founded in 1700. Registered in 1911. From 1943 it traded as City & St Anne's (Norman & Pring) Ltd. Acquired by Whitbread & Co. Ltd in April 1962 with 102 tied houses and the business was merged with Starkey, Knight & Ford Ltd in 1964. Brewing ceased at the City Brewery in 1956 when production was concentrated at the St Anne's Well Brewery, but bottling continued until 1968 when the brewery burnt down.

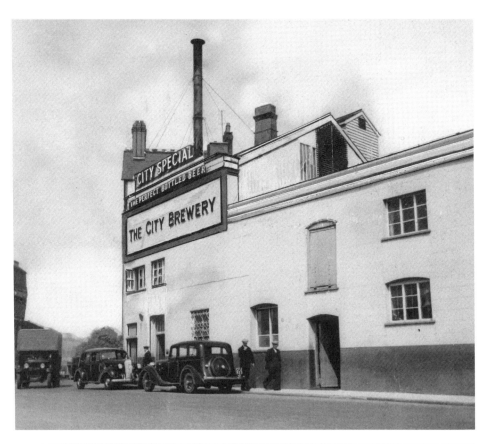

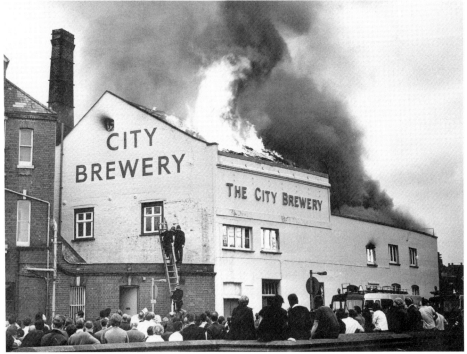

Tayler & Co., Cotswold Brewery, Northleach, Gloucestershire. Acquired by the Cheltenham Original Brewery Co. Ltd in 1919 with fourteen tied houses. Buildings still extant as housing.

Offiler's Brewery Ltd, 7 Ambrose Street, Normanton Road, Derby. Founded in 1876 when George Offiler acquired the Vine Inn brewery, Whitaker Street. Ambrose Street was acquired from the Star Tea Warehouse and converted into a brewery in 1884. Registered in November 1890 and reconstructed company formed in February 1892. Acquired by Charrington United Breweries in 1965 with 238 properties and was closed on 30 September 1966.

Above and opposite: James Paine Brewery Ltd, John Bull Brewery, Market Square, St Neots, Cambridgeshire. Founded in 1831 when James Paine acquired the brewery site. Registered as Paine & Co. Ltd in July 1896. Destroyed by fire on 19 October 1905 but rebuilt the following year. Acquired by a group of travel agents in 1982 and renamed as above. Acquired by Tollemache & Cobbold Breweries Ltd in 1987 and ceased brewing. Listed brewery buildings converted into riverside apartments, with the Market Square facade retained.

There are still numerous old brewing company signs still around. This one is in South London and magnificently advertises John Lovibond, who had breweries in Greenwich and Salisbury.

The brewers used local advertising to a great extent. Here Woolf's Ltd of the South Cheshire Brewery, 44/48 Wistaston Road, Crewe took great pride in proclaiming their beers. The company was founded in 1871. Acquired by Ind Coope Ltd in 1923 with forty-two public houses and was then closed.

During the twentieth century the brewers consolidated themselves and larger and larger firms began to emerge. Improved transportation methods and more and more capacity in breweries allowed firms to supply further and further afield. Small successful local brewers were becoming large regional brewers by purchasing their weaker rivals in town, then their rivals in the next town and eventually for some, their rivals in the county. This gave us names which even now can be recalled very easily by some generations. Names that would, certainly at that time, immediately mean a certain part of the country. Names such as Fremlins (Kent), Greene King (Suffolk), Stones (Sheffield), Boddingtons (Manchester), McEwans (Scotland) etc. Often the takeover was just an excuse to get their hands on the tempting estate of pubs which came with it. These were seen as the jewel in the crown as the regional brewers often held large portfolios of local pubs. As a result the premises of the local brewery were often superfluous and were sold off for development and alternative use with impolite haste. Admittedly, sometimes the site was utilised by the acquirer as a depot, reminding us that transportation techniques had still got some way to go.

The owners of the big breweries realised that by 'tying' the owners and tenants of public houses to their brewery, great sales opportunities were available. This lead to a land grab. Pubs and off-licences were bought up in great numbers so the large breweries started to own and control vast estates of public houses. This was done in several ways. Selective pub purchases happened as one brewery traded pubs with another. The biggest and quickest way to increase ones estate was simply to take over the brewery. Often great swaths of the estate would suddenly switch from one brewer's beers to another as the takeover took hold.

As the First World War trundled on, keeping up output was key. However, it was clear that the fairly open attitude to pubs and drinking were taking their toll. Lloyd George said in 1915 that Britain was fighting the Germans, the Austrians and drink, and the greatest of all these was drink. His government introduced the very familiar opening hours that have only recently been repealed or relaxed, 11 a.m. until 2 p.m., not on Sunday, and 5 p.m. until 10 p.m. etc. The brewers were smart and realised that reduction of available materials during times of conflict gave them an excuse to reduce the strength of their beers with little repercussions and lots of tax saved. When those materials became more available they did little to restore brews back to those higher alcoholic strengths.

The brewers responded to protect their reputations and their products. They came up with an answer that is still with the industry today. They invented the tied house system. By creating a link between the brewer and the publican, they were able to directly influence the point of sale. Thus, the common brewer was now able to control the production, distribution and retailing of their ales and beers. They gained total power over the product. By the 1960s the large brewing companies began to dictate how the beer should taste and how it would be stored. However, this was soon the cause of the real ale rebellion which gave birth to CAMRA, potentially the most successful consumer revolt of the twentieth century.

As our story arrives in the early 1970s we find that because of the drive for profit and economy, many of the large regional brewers had been absorbed in various ways into large national combines. All of these were very familiar names to those enjoying beer and pubs at the time but have recently disappeared from view. The brewing giants of the

1970s, known colloquially as the Big Six, had reached a point of vertical integration. They controlled the entire brewing process from raw materials to served pint. Their names were Bass, Courage, Scottish & Newcastle, Whitbread, Watney and Allied.

We have the benefit of hindsight to analyse how these once-mighty companies met their end. The industry was naturally evolving to central and national brewing, the repeated recessions, an increase in taxation matched with a decrease and diversification in demand. In 1989 the Big Six employed over 500,000 people in brewing and retailing with 80 per cent of beer production under their corporate belts. That year, the relatively small (by comparison with the members of the Big Six) company of Scottish & Newcastle was threatened with takeover by Elders XL. They were an Australian company who had already swallowed Courage. They saw this as a way of getting their flagship beer, Fosters, into the British market. This triggered a reaction from not only the beer lovers of Britain, but also the government of the day. They were worried about so much of the market being controlled by one company so they set the Monopolies and Mergers Commission on to the job. The government became concerned that they investigated the matter and concluded that the merger would not be in the public interest; they blocked the merger and in turn instigated a wider Monopolies and Mergers Commission report into 'The Supply of Beer'. Running to over 500 pages, it concluded that there was already a 'complex monopoly' in operation among the Big Six.

The Monopolies and Mergers Commission Report in 1989 changed the face of the pub trade. They recommended structural change. The two major recommendations were firstly, to increase choice it was necessary for a major brewing chain to allow another brewer's ales to be sold in tied houses (hoping to stimulate growth and wider competition among the smaller regional brewers, this introduced the popular 'guest ale' that is widely used by landlords). The second limited the number of tied houses that could be owned by a brewery, and each of the Big Six were forced to restrict their tied estates to a mere 2,000 houses each. The result was the disposal of thousands of public houses and the creation of a number of pub-owning companies. Firms such as Midsummer Inns and JD Wetherspoon. Some brewers simply stopped brewing to concentrate on the retailing side.

Despite the backing of the government, the recommended changes were not fully implemented. The response from the Big Six was not what the government had intended nor expected. Greenall Whitley, Boddingtons and Devenish, all long-standing brewers with respected products, took the opportunity to divest themselves of their brewing activities and to concentrate on retailing, thus circumventing the need to restrict their tied estates to a mere 2,000 outlets. Others sold off their excess pubs, but to independent pubcos that they controlled, but with beer supply clauses. Less than a quarter of tied houses implemented the guest beer ruling. Two of the Big Six did a crafty pubs and breweries swap in an attempt to sidestep the legislation. Grand Metropolitan (the Watney, Mann, Truman owners) swapped their brewing capabilities with Courage, leaving a massive brewer and a massive pub owner – neither contravening the MMC ruling. Courage itself then got taken over by (of all people) Scottish & Newcastle, finally achieving the very thing the MMC had earlier stopped! Thus one huge brewing group was created at the same time

as one huge pub owning group. To mop up the sudden flood of pubs onto the market there began appearing non-brewing pub-owning groups. This new conglomerate was now larger than their rival Bass, who attempted to win back some bragging rights with a merger with Carlsberg-Tetley. Once again the government intervened in this plan and the Department of Trade and Industry blocked it.

Bass, and fellow Big Six member Whitbread, limped on in the 1990s until in 2000 the Belgian firm Interbrew mopped up both. If I may for a moment relate a short story about how some of the takeovers were sold to the shareholders of the target company: in 1987 Scottish & Newcastle acquired Blackburn brewers Matthew Brown, a sizable local brewer and owner of 550 tied houses – clearly the target. Among the predictable outcry from local and national drinkers, Scottish & Newcastle announced that they would continue brewing at Brown's Blackburn brewery and that the preservation of the name and their beers was 'sacrosanct'. Within three years the Brown site had been disposed of and the beer just a memory. Scottish & Newcastle took over Courage to become Scottish Courage, but by 2003 they sold their estate to Punch Taverns.

Now the big brewers are all owned by overseas global brewers, their remains are inside AB Inbev UK Ltd, Carlsberg UK Brewing Ltd, Heineken UK Ltd and Molson Coors Brewing Co (UK) Ltd, but all is not lost. Admittedly, the second Beer Order instruction of a guest beer policy in remaining tied houses paved the way for some of the smaller brewers to get their products into a far wider area and kick-started the micro revolution still going on today.

To summarise this dramatic change in the beer and pubs landscape of the UK:

Date	Owned by Big Six	Owned by Pub Companies
1989	44,100	
1993	26,200	14,800
2003	8,400	32,900

The Retail Outlet

The British public house is a bit of a mongrel. It has absorbed many influences over the centuries. Some of its origins can be seen in the alehouses of Egypt, others from the taverns of Ancient Rome. A Roman drinking establishment, like its Egyptian predecessor and its British offspring, was easily identifiable by a bush or stake displayed outside. Sometimes they were modest affairs and sometimes reflections of status and wealth. For example, in 1655 the good citizens of Scole in Norfolk erected a pub sign which bridged the entire high street. The erection cost a mere £1,000. Often the coat of arms of the local lord of the manor was used. These have been handed down to use over the centuries and explain the White Horse, Red Lion and Spread Eagles. Sadly they were not the safest form of advertising as a sign in Fleet Street London collapsed and killed two passers-by. In 1714 the death of two young ladies was reported when a large cross street inn sign fell on them.

The departure of the Romans left the country devoid of structure and organisation. The Roman drinking houses fell into disuse and were replaced by the altogether more bawdy alehouses of the marauding Saxons and Vikings. These were mainly drinking establishments. The hospitality side of the business moved over to the monasteries, where the monks set aside a portion of their buildings for the weary traveller.

On the dissolution of the monasteries brewing went into the hands of the publican breweries, who brewed beer to sell in their own inns. Some of these are still in existence, for example the Blue Anchor, in Helston, Cornwall, and The Three Tuns, Bishops Castle, Shropshire. The oldest dates back to the twelfth century.

Inns and taverns became the more respectable spin-offs from the alehouse. During the seventeenth and eighteenth centuries it became fashionable to be seen in a tavern. Some of the greatest creators of literature assembled to discuss and develop their art. Indeed, the great Doctor Johnson was a frequent visitor to the taverns of London. His words are still relevant: 'No Sir, there is nothing which has yet been contrived by man, by which so much happiness is produced, as by a good tavern or inn.'

There is no strict legal definition that describes retail outlets. One can assume that taverns and coaching houses provided food, lodging and of course beer, and that beer or alehouses just traded in the latter. A safe assumption but not strictly followed. For the sake of this brief stroll through our beer-based history, let us just refer to all the variations as public houses, for that essentially covers all of them. Public houses were somewhere that the public could obtain sustenance and beverages; a place where one could obtain lodgings and meals as well as drinking the local brews; a development from the alehouse. Early examples were the medieval church hostels, who only served travellers, where the guest would find an earthen floor, sometimes paved with stone slabs, and occasionally covered with rushes. The guests slept in dormitories with men and women sharing the communal beds. In 1129 a German

ambassador wrote in a visitors' book: 'The inns of England are the best in Europe.' However, they were not without their critics and their opponents. In 1329 an example of state control was introduced in London via a proclamation that said: '... we forbid that any taverner or brewer keep the door of his tavern open after the hour of curfew.'

Having waxed lyrical about the rise of the great brewers of Britain, it must be recorded that they and their products were under constant threat. Public taste, then as well as now, was fickle and subject to the latest fashion. The arrival in the eighteenth century of tea and coffee made significant indents in the brewers' sales. The more freely available spirits gave beer a run for its money. Let me be trite here and repeat the infamous marketing claim of the gin retailers: 'Drunk for 1d and dead drunk for 2d.'

It is worth mentioning that brewers were partly to blame for the increase in spirit drinking as towards the end of the eighteenth century they began to hike up the cost of beer. They contrived to increase prices in the 1790s, thereby forcing the working classes to seek more economic ways of drowning their sorrows. The government didn't help either when they lowered excise duty on spirits in 1823.

The brewers were not stupid and realised what was happening to their previously good income generators. One ploy was to try and secure their retail outlets. The public house, in all its guises, was the premier outlet for a brewer's product, off sales having not made inroads such as is seen today. Therefore, the brewers reasoned, if they could control the supply to these premises they could control the sale of their product and maximise sales. Subsequently, they began a policy of pub acquisition; a policy that ran for over 200 years. The tied estate was born, not out of philanthropy towards the landlord but out of fear of lost profit opportunities.

This was not an original good idea. In 1319 Thomas Drinkwater granted a lease to James Beaufleur for the Bear in London in return for which he agreed to take all his wine from Drinkwater – thus the brewery-tied-house model was born.

There are numerous ways of viewing the brewery tie and the development of the public house estate. Modern business gurus would point out it is just vertical integration, putting the method of sale in the control of the manufacturer. After all it was not unusual for breweries to own hops growing yards or malting facilities. What made more business sense than controlling the outlets that your product appeared in. It had its down side, mainly for the publican. Limited choice, lack of investment in a poor performer, prices under strict control and restricted sales materials. However, one of the unforeseen side effects was that the smaller local breweries, even the regional ones, became tempting targets, not for the quality of their beers or even the size of their brewery premises. Simply, they were taken over for their tied house estate. The accountants at the brewery saw that rather than wait for a pub to come on the market to increase their estate, it made more sense to buy a parcel of pubs by buying a small brewery. Sometimes this was an aggressive strategy and sometimes not. Some breweries were sold merely because their tied estate was inexcusably undervalued on the balance sheet. Some were taken over as the brewery had not got the capital available to enhance its outlets. Others just made a grab for the pile of cash being waved at them.

The mass production and national distribution gave us Double Diamond, Watneys Red Barrel, Whitbread Trophy and Courage Tavern. Limited choice and dwindling local brewers gave us CAMRA. Maybe a short-term policy now that there are hundreds of micros in the market supplying small volumes to discerning drinkers.

With the national brands came national advertising and the new tool of the marketers – commercial television. Advertising jingles, cartoon characters and outrageous promises of increased personal vigour.

However, the drinking public was not stupid, we knew we were being manipulated and we were just biding our time.

The Great Take Home Revolution

You may think that because of the ongoing debate about the impact of home drinking and its effect on the more traditional retail outlets, that transporting beer away from the pubs and taverns is a recent phenomenon. Not so!

While current technology has given us cans with widgets and polypins, containers designed for the individual to carry around drinks are centuries old. In 1373 there was a trade guild called the Ministry of Bottlemakers. However, the use of glass to safely hold beer, or any other form of liquid come to that, needed a few more centuries to evolve. So in 1568 we find another one of those brilliant accidental ideas coming to Dr Alexander Nowell. He was, at the time, the Dean of St Paul's Cathedral. He was a lover of fishing and somewhat absent minded. Deciding that this was a good day to take his rods out for a session, he placed some locally brewed ale in a wine bottle and corked it down tight, which he correctly surmised to be an ideal method for transporting his preferred refreshment. Inspirationally, divine or otherwise depending upon your personal beliefs, he decided to cool it in the waters of the Thames. As a result of his absent mindedness, he forgot the bottle and headed home with his catch. On his return several days later the ale was in perfect condition.

While this discovery was not fully appreciated by the bemused dean, we know that in 1676 the household records of the Russell family, who's country seat was at Woburn, Bedfordshire, identifies 'ale to bottle for my Lord's drinking'. In 1683 social commentator Thomas Tryton informs his reading public: 'It is a great custom and general fashion nowadays to bottle ale ... (and) ale out of bottles will drink more cold and brisk but not so sweet and mild as the same ale out of a cask'. He then goes on to advise his readers not to follow this fashionable pursuit.

The seventeenth century saw the further rise of bottled beer. Technology had advanced sufficiently that vessels were now able to contain the liquid. As a writer in 1691 warned, 'all such bottle drinks are infected with a yeasty furious foaming matter which no barrel-ale is guilty of ... for which reason bottle-ale or beer is not so good or wholesome as that drawn out of the barrel or hogshead; and the chief thing that can be said for bottle-ale or beer, is that it will keep longer than that in barrels.'

Ironically, having packed beer into glass bottles and having corked and cooled them, it is not until 1720 – over a hundred years later – that we have the first mention of a 'bottle scrue' or corkscrew. History doesn't tell us how they were opened before that time!

The drawback for provincial brewers who used bottles for their product was cost. Burton ale was advertised in 1712 at 7s 6d for a dozen bottles, significantly higher than locally produced beer. It is perhaps an early reflection of our present-day fascination for the exotic, the fashionable and our appetite for wider choice.

In 1776, Benjamin Kenton became Master of the Vintner's Company. Using his influential position, and specific knowledge, he is said to have made a vast fortune teaching brewers the secrets of bottling their beers and ales. However, the bottling of beer did not start in a big way until after the repeal of the Glass Excise Act in 1834. Early bottles were expensive to produce and tended to have a glass seal on the shoulder of the bottle identifying the owner. In 1843 Bass & Co. used a small circular label made of paper on the neck of the bottle. From the 1850s onwards many different breweries used paper labels, and by then they were stuck onto the main body of the bottle and became much larger, the most common shape being oval. The greater use of labels was brought about by the growth of railway transport and the increased availability of non-local beer.

In 1864 Patent Number 1188 was lodged to register the idea of bottling draught beer using top pressure of carbon dioxide to maintain freshness. Until the 1880s, beer was bottled and corked by hand, this is a process known as 'flogging'. The availability of bottling machinery provided the brewers with the ability to greatly increase the volume of bottled beer they were able to handle. Whitbread had opened their first bottling stores in 1868, and by 1885 machinery was in place which could handle 30 gross tons of bottles per day.

Early bottles were corked (and sometimes wired). Barrett's of London invented the screw stopper in 1885 and the crown cork was invented in 1908. The passing of the Children's Act in 1902 required the use of a stopper label on each bottle. Most breweries introduced bottled beers at this time, and the range and variety expanded greatly. The design and printing of labels was undertaken by jobbing printers, but gradually production became concentrated into specialist printing firms.

Just after the Second World War, a brewer from the Midlands called Davenports of Birmingham had the foresight to start targeting the home trade rather than fight it. While it had been acceptable for many decades to nip down to the pub for some to take away, Davenports began to advertise 'Beer At Home' as an encouragement to drinkers.

Bottling beer into glass containers became another source of revenue for the brewers of Britain. However, as they automated and streamlined production, another form of beer packaging was struggling to be born on the other side of the Atlantic. In 1909, the American Can Company had tried to produce a can for beer but with no success. They tried again in 1931, spurred on by the end of Prohibition. This time technology had moved on and things were more successful. However, they could not gain the support of any of the American brewers they approached. They decided to give it one more try and met with a small ailing brewer with an offer to jointly produce tinned beer, the can company paying for all expenses. The brewers had little to lose and were desperate to increase sales. A limited run of beer in cans was produced during 1933 and modifications were made to the design and manufacture during 1934.

We Brits were not too impressed with this idea. In 1934, Mr Sanders-Watney, Director of the London brewers Watney, Combe and Reid, stated in an article: 'I am not convinced that there would be any demand in this country for beer in cans. I cannot conceive the idea of a can ever replacing the half-pint or quart bottle. The canning habit is certainly growing, but

I do not think it will spread to drinks.' That's not that we didn't give it a go. As early as 1812 brewers and victuallers had been trying to capture the taste of beer in a can. The advocates pointed out that beer and ale has been drunk in pewter tankards in public houses for hundreds of years, so what was so strange about drinking it from a tin away from the bar? Those early experiments failed because the technology of the time was unable to support the high pressures generated by the beer when inside the can. The experiments had all failed when the seam burst or constantly leaked the contents through the seals.

In 1935, under the trade name 'Kegliner', the Krueger Brewery's Finest Beer and Cream Ale went on public sale in Richmond, Virginia. It was an instant success. By the end of the same year over thirty-five American brewers were setting up canning lines. This commercial good news travelled over the Atlantic extremely quickly, but it was not the big British brewers who were listening. The first attempts to make beer cans in Britain was made by a small tinplate manufacturer in South Wales looking to expand a declining market for their product.

Two local provincial brewers from Wales, Buckleys and Felinfoel were also keen to expand their sales and offered to join forces. By December 1935, Felinfoel had begun producing their pale ale in conical cans of 10 oz capacity. The full public launch came in early 1936 and these soon caught the public imagination. Shaped the same as the widely available metal polish tins 'Brasso', they soon acquired this trade name as a nickname. By the end of 1936 most brewers in the UK had jumped on the canning bandwagon and over 2 million units had been produced.

One for the Road

I have gone on too long. I see your glass is empty.

This was just a brief tour of the history of brewing in Britain. There can be no doubt that it is long and complex and full of myth and legend, and sometimes downright misinterpretation. Well, after this tale of ale and beer and brewers it is not surprising that you are in need of some more! Feel free – there is plenty of choice. You are one of an increasing number of consumers who care about this product of our island nation. Your interest in the product, in the way it is produced and the companies, old and new, who make it is key in securing the future.

Looking at the beer market today makes it difficult to read and very hard to predict. The multitudes of micros and brew pubs has increased choice dramatically: the old school Big Six have all disappeared; the duty payable on beer has been scaled to allow small and large production to be done on an equitable basis. However, it cannot have failed to escape your notice that pub closures are all over. Not a week goes by without some press story reporting a pub closing down after thousands of years – apologies for my exaggeration, but I'm sure you appreciate my point. Rationalisation is perhaps a glib way of saying it but pub-goers want more these days than just beer. They want food, they want entertainment, they want variety in their drinks and they want all this in comfortable surroundings – and only they can define comfortable. So, as Darwin's Big Idea proved with the natural world: adapt or die.

Before you go, have you ever thought of taking a walk through the history of your pint? It is surprising how many of the buildings that produced beer are still around. Admittedly nearly all of them are doing something very different from their original intention, but the bricks and mortar remain. If I may make a final quip, there in body but not in spirit, take a look at the illustrations that accompany this book. Some of these temples of beer are still with us; some still brew, others have been converted into other uses, many have disappeared; many towns have something to look at.

There is always more to read, and if your curiosity has been roused please feel free to follow up the story in greater detail using the list of books in the bibliography. It can be very rewarding and often strange facts turn up when you are least expecting them. For example, did you know that in the early days of Everton Football Club they officially played on a field belonging to Orrell Brother's brewery on Anfield Road? In 1891, Everton was in dispute with local brewer John Houlding over rent for the field which he now owned (thanks to the takeover boom that was beginning). Eventually, they were forced to find alternative accommodation and settled down at Goodison Park. Houlding rented out the Anfield ground to a newly formed Liverpool United. Houlding's Brewery survived until 1938 when they were acquired by Ind Coope Ltd. No trace of the brewery now remains, but

the two football clubs with which he was connected have become known to millions. The building which is featured on the Everton badge is believed to be Everton Beacon, which was also John Houlding's trademark, registered by him in January 1888. In 1897 Aston Villa transferred their home ground to Villa Park, which at the time was owned by Flower's Brewery of Stratford-upon-Avon. Charrington & Co., an ambitious East London Brewer, owned a small, disused nursery garden in Tottenham, north London. In 1899 they entered into an agreement with the local football team to rent them the site which they named after a local public house, the White Hart. In 1906, Oldham Athletic moved to their home ground which was then owned by brewer J. W. Lees Ltd. Ipswich United had close links with the Cobbold brewing family. The Race Course Ground of Wrexham United was once owned by Border Breweries Ltd. Barnsley's ground is adjacent to the site of the Oakwell Brewery. In 1921, Watford Football Club had the Vicarage Road ground bought for them by local brewers Benskins. Of course, the directors of the brewery insisted on a place on the Watford Board in exchange for their generosity. In 2001 the club purchased the ground back from Punch Taverns, the final owner after nearly a century of change and turmoil.

I leave you in convivial surroundings, tasting a drink that has satisfied and refreshed mankind for over 6,000 years, and long may it continue. Finally, I close with the words of Anglican cleric, essayist and social commentator Sydney Smith: 'what two ideas are more inseparable than beer and Britannia?' – as true today as they were when he wrote them in the eighteenth century.

Your very good health!

Bibliography

Clark, Peter, *The English Alehouse: A Social History 1200-1830* (London: Longman Higher Education, 1983).

Cornell, Martyn, *Amber, Gold and Black: The History of Britain's Great Beers* (Stroud: The History Press, 2010).

Haydon, Peter, *Beer and Britannia: An Inebriated History of Britain* (Stroud: Sutton Publishing Ltd, 2001).

Hornsey, Ian. S., *A History of Beer and Brewing* (London: Royal Society of Chemistry, 2003).

Gourvish, T. R. and R. G. Wilson, *The British Brewing Industry 1830 to 1980* (Cambridge: Cambridge University Press, 1994).

Monckton, H. A., *A History of English Ale and Beer* (London: The Bodley Head, 1966).

Peaty, Ian P., *Brewery Railways: An Historical Survey* (Newton Abbot: David & Charles, 1985).

Smith, Greg, *Beer in America, The Early Years 1587 to 1840* (Boulder: Brewers Publications, 1998).

Starkey, David, *Magna Carta: The True Story Behind the Charter* (London: Hodder & Stoughton, 2015).

The Brewery History Society

The Brewery History Society was founded in April 1972 to bring together people with a common interest in the history of brewing, to stimulate research and to encourage the exchange of information. To this end members receive a quarterly Journal – *Brewery History* – which contains articles about brewers and breweries from as early a date as possible. In addition they will get a quarterly Newsletter containing up-to-date news of mergers, takeovers and new small breweries. It also provides a platform for members to ask (and answer) research conundrums.

Meetings are held in different parts of the country at which members can get together for a chat and a pint or two and regular visits to breweries and maltings are arranged.

The society has an archivist whose responsibility it is to safeguard the books and research material acquired by the society. He will endeavour to answer specific enquiries from both members and the general public, or will pass them on to the appropriate expert. These are volunteers who take responsibility for correlating research within their own area whilst liaising with the archivist. The society has an archive of material relating to the brewing industry lodged with the History of Advertising Trust in Norfolk. A photographic collection is maintained to which members are encouraged to donate copies of their own photographs. Copies of photographs in the collection may be purchased. The society also maintains a bookshop which holds a large stock of new and second-hand books on beer and brewing.

Upon joining, new members will receive a copy of the journal, a copy of the Rules and Constitution and current bookshop list.